Very Short Introductions available now:

ACCOUNTING Christopher Nobes
ADVERTISING Winston Fletcher
AFRICAN HISTORY
 John Parker and Richard Rathbone
AGNOSTICISM Robin Le Poidevin
ALEXANDER THE GREAT Hugh Bowden
AMERICAN HISTORY Paul S. Boyer
AMERICAN IMMIGRATION David A. Gerber
AMERICAN POLITICAL PARTIES AND
 ELECTIONS L. Sandy Maisel
AMERICAN POLITICS Richard M. Valelly
THE AMERICAN PRESIDENCY Charles O. Jones
ANAESTHESIA Aidan O'Donnell
ANARCHISM Colin Ward
ANCIENT EGYPT Ian Shaw
ANCIENT GREECE Paul Cartledge
THE ANCIENT NEAR EAST Amanda H. Podany
ANCIENT PHILOSOPHY Julia Annas
ANCIENT WARFARE Harry Sidebottom
ANGELS David Albert Jones
ANGLICANISM Mark Chapman
THE ANGLO-SAXON AGE John Blair
THE ANIMAL KINGDOM Peter Holland
ANIMAL RIGHTS David DeGrazia
THE ANTARCTIC Klaus Dodds
ANTISEMITISM Steven Beller
ANXIETY Daniel Freeman and Jason Freeman
THE APOCRYPHAL GOSPELS Paul Foster
ARCHAEOLOGY Paul Bahn
ARCHITECTURE Andrew Ballantyne
ARISTOCRACY William Doyle
ARISTOTLE Jonathan Barnes
ART HISTORY Dana Arnold
ART THEORY Cynthia Freeland
ASTROBIOLOGY David C. Catling
ATHEISM Julian Baggini
AUGUSTINE Henry Chadwick
AUSTRALIA Kenneth Morgan
AUTISM Uta Frith
THE AVANT GARDE David Cottington
THE AZTECS David Carrasco
BACTERIA Sebastian G. B. Amyes
BARTHES Jonathan Culler
THE BEATS David Sterritt
BEAUTY Roger Scruton
BESTSELLERS John Sutherland
THE BIBLE John Riches
BIBLICAL ARCHAEOLOGY Eric H. Cline
BIOGRAPHY Hermione Lee
THE BLUES Elijah Wald
THE BOOK OF MORMON Terryl Givens
BORDERS Alexander C. Diener and Joshua Hagen
THE BRAIN Michael O'Shea
THE BRITISH CONSTITUTION Martin Loughlin
THE BRITISH EMPIRE Ashley Jackson
BRITISH POLITICS Anthony Wright
BUDDHA Michael Carrithers
BUDDHISM Damien Keown
BUDDHIST ETHICS Damien Keown
CANCER Nicholas James
CAPITALISM James Fulcher
CATHOLICISM Gerald O'Collins
CAUSATION Stephen Mumford and Rani Lill Anjum
THE CELL Terence Allen and Graham Cowling
THE CELTS Barry Cunliffe
CHAOS Leonard Smith
CHILDREN'S LITERATURE Kimberley Reynolds

CHINESE LITERATURE Sabina Knight
CHOICE THEORY Michael Allingham
CHRISTIAN ART Beth Williamson
CHRISTIAN ETHICS D. Stephen Long
CHRISTIANITY Linda Woodhead
CITIZENSHIP Richard Bellamy
CIVIL ENGINEERING David Muir Wood
CLASSICAL LITERATURE William Allan
CLASSICAL MYTHOLOGY Helen Morales
CLASSICS Mary Beard and John Henderson
CLAUSEWITZ Michael Howard
CLIMATE Mark Maslin
THE COLD WAR Robert McMahon
COLONIAL AMERICA Alan Taylor
COLONIAL LATIN AMERICAN
 LITERATURE Rolena Adorno
COMEDY Matthew Bevis
COMMUNISM Leslie Holmes
COMPLEXITY John H. Holland
THE COMPUTER Darrel Ince
THE CONQUISTADORS Matthew Restall and
 Felipe Fernández-Armesto
CONSCIENCE Paul Strohm
CONSCIOUSNESS Susan Blackmore
CONTEMPORARY ART Julian Stallabrass
CONTEMPORARY FICTION Robert Eaglestone
CONTINENTAL PHILOSOPHY Simon Critchley
CORAL REEFS Charles Sheppard
COSMOLOGY Peter Coles
CRITICAL THEORY Stephen Eric Bronner
THE CRUSADES Christopher Tyerman
CRYPTOGRAPHY Fred Piper and Sean Murphy
THE CULTURAL REVOLUTION
 Richard Curt Kraus
DADA AND SURREALISM David Hopkins
DARWIN Jonathan Howard
THE DEAD SEA SCROLLS Timothy Lim
DEMOCRACY Bernard Crick
DERRIDA Simon Glendinning
DESCARTES Tom Sorell
DESERTS Nick Middleton
DESIGN John Heskett
DEVELOPMENTAL BIOLOGY Lewis Wolpert
THE DEVIL Darren Oldridge
DIASPORA Kevin Kenny
DICTIONARIES Lynda Mugglestone
DINOSAURS David Norman
DIPLOMACY Joseph M. Siracusa
DOCUMENTARY FILM Patricia Aufderheide
DREAMING J. Allan Hobson
DRUGS Leslie Iversen
DRUIDS Barry Cunliffe
EARLY MUSIC Thomas Forrest Kelly
THE EARTH Martin Redfern
ECONOMICS Partha Dasgupta
EDUCATION Gary Thomas
EGYPTIAN MYTH Geraldine Pinch
EIGHTEENTH-CENTURY BRITAIN Paul Langford
THE ELEMENTS Philip Ball
EMOTION Dylan Evans
EMPIRE Stephen Howe
ENGELS Terrell Carver
ENGINEERING David Blockley
ENGLISH LITERATURE Jonathan Bate
ENVIRONMENTAL ECONOMICS Stephen Smith
EPIDEMIOLOGY Rodolfo Saracci
ETHICS Simon Blackburn

Rebecca Arnold

FASHION

A Very Short Introduction

OXFORD
UNIVERSITY PRESS

OXFORD
UNIVERSITY PRESS

Great Clarendon Street, Oxford OX2 6DP

Oxford University Press is a department of the University of Oxford.
It furthers the University's objective of excellence in research, scholarship,
and education by publishing worldwide in

Oxford New York

Auckland Cape Town Dar es Salaam Hong Kong Karachi
Kuala Lumpur Madrid Melbourne Mexico City Nairobi
New Delhi Shanghai Taipei Toronto

With offices in

Argentina Austria Brazil Chile Czech Republic France Greece
Guatemala Hungary Italy Japan Poland Portugal Singapore
South Korea Switzerland Thailand Turkey Ukraine Vietnam

Oxford is a registered trade mark of Oxford University Press
in the UK and in certain other countries

Published in the United States
by Oxford University Press Inc., New York

British Library Cataloguing in Publication Data

Data available

Library of Congress Cataloging in Publication Data

Data available

Typeset by SPI Publisher Services, Pondicherry, India
Printed in Great Britain by
Ashford Colour Press Ltd, Gosport, Hampshire

ISBN 978-0-19-954790-6

5 7 9 10 8 6 4

For Adrian

Contents

Acknowledgements

I would like to thank Andrea Keegan, my editor at Oxford University Press, for her support and encouragement of this project. Thanks to all my colleagues and the students of the History of Design Department at the Royal College of Art in London. I am indebted to Caroline Evans for her excellent advice, and to Charlotte Ashby and Beatrice Behlen for their thoughtful comments on drafts. Thank you to Alison Toplis, Judith Clark, and Elizabeth Currie for their helpful suggestions. And finally, thanks to my family, and to Adrian Garvey for everything.

List of illustrations

Introduction

Malign Muses, Judith Clark's groundbreaking 2005 exhibition at
the Mode Museum in Antwerp, brought together recent and
historical dress in a spectacular series of tableaux. The setting was
designed to look like a 19th-century fairground, with simple plain
wooden structures that evoked carousels, and oversized black and
white fashion drawings by Ruben Toledo, which added to the
feeling of magic and showmanship. The exhibition emphasized
fashion's excitement and spectacle. Intricate designs by John
Galliano and Alexander McQueen mixed with interwar couture,
including Elsa Schiaparelli's 'skeleton dress', a black sheath
embellished with a padded bone structure. A dramatic 1950s
Christian Dior evening dress in crisp silk, with a structured bodice
and sweeping skirt, caught with a bow at the back, was shown, as
was a delicate white muslin summer dress made in India in the late
19th century, and decorated with traditional chain stitch
embroidery. Belgian designer Dries Van Noten's jewel-coloured
prints and burnished sequins of the late 1990s stood next to a
vibrantly hued Christian Lacroix ensemble of the 1980s. This
extravagant combination of garments was rendered
comprehensible by Clark's cleverly designed sets, which focused
on the varied ways in which fashion uses historical references.
The exhibition's theatrical staging connected to 18th-century
Commedia del Arte shows and masquerades, and linked directly to

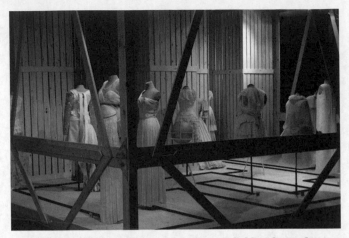

1. A tableau from the *Malign Muses* exhibition held at the Mode Museum in Antwerp in 2005, designed and curated by Judith Clark

contemporary designers' use of drama and visual excess in their seasonal catwalk shows.

Malign Muses was later staged at the Victoria and Albert Museum in London, where it was renamed as *Spectres: When Fashion Turns Back*. This new title expressed one of the contradictions at the heart of fashion. Fashion is obsessed with the new, yet it continually harks to the past. Clark deployed this central opposition to great effect, encouraging visitors to think about fashion's rich history, as well as to connect it to current issues in fashion. This was achieved through the juxtaposition of garments from different periods, which used similar techniques, design motifs, or thematic concerns. It was also the result of Clark's close collaboration with fashion historian and theorist Caroline Evans. By using Evans' important insights about fashion and history from her 2003 book *Fashion at the Edge: Spectacle, Modernity and Deathliness*, Clark revealed fashion's hidden impulses. Evans shows how influences from the past haunt fashion, as they do the

wider culture. Such references can add validity to a new, radical design, and connect it to a hallowed earlier ideal. This was apparent in the fragile pleats of the Mme Grès dress included in the show, which looked to classical antiquity for inspiration. Fashion can even speak of our fears of death, in its constant search for youthfulness and the new, as evoked by Dutch duo Viktor and Rolf's all-black gothic-inspired gown.

Visitors could therefore not only see the visual and material aspects of fashion's uses of history, but through a series of playfully constructed vignettes, they were able to question the garments' deeper meanings. In a continuation of the exhibition's fairground theme, a series of carefully conceived optical illusions used mirrors to trick the viewer's eye. Dresses seemed to appear then disappear, were glimpsed through spy-holes, or were magnified or reduced in size. Thus, visitors had to engage with what they were looking at, and question what they thought they could see.

They were prompted to think about what fashion means. In contrast to clothing, which is usually defined as a more stable and functional form of dress that alters only gradually, fashion thrives on novelty and change. Its cyclical, seasonally shifting styles were evoked by Toledo's circular drawing of a never-ending parade of silhouettes, each different from the next. Fashion is often also seen as a 'value' added to clothes to make them desirable to consumers. The exhibition sets' glamour and theatricality reflected the ways that catwalk shows, advertising, and fashion photography seduce and tempt viewers by showing idealized visions of garments. Equally, fashion can be seen as homogenizing, encouraging everyone to dress in a certain way, but simultaneously about a search for individuality and expression. The contrast between couture's dictatorial approaches to fashion in the mid-20th century, embodied by outfits by Dior, for example, was contrasted with the diversity of 1990s fashions to emphasize this contradiction.

This led visitors to understand the different types of fashion that can exist at any one moment. Even in Dior's heyday, other kinds of fashionable clothing were available, whether in the form of Californian designers' simple ready-to-wear styles, or Teddy boys' confrontational fashions. Fashion can emanate from a variety of sources and can be manufactured by designers and magazines, or develop organically from street level. *Malign Muses* was therefore itself a significant moment in fashion history. It united seemingly disparate elements of past and present fashions, and presented them in such a way that visitors were entertained and enthralled by its sensual display, but led to understand that fashion is more than mere surface.

As the exhibition revealed, fashion thrives on contradiction. By some, it is seen as rarefied and elite, a luxury world of couture craftsmanship and high-end retailers. For others, it is fast and throwaway, available on every high street. It is increasingly global, with new 'fashion cities' evolving each year, yet can equally be local, a micro fashion specific to a small group. It inhabits intellectual texts and renowned museums, but can be seen in television makeover shows and dedicated websites. It is this very ambiguity that makes it fascinating, and which can also provoke hostility and disdain.

Fashions can occur in any field, from academic theory to furniture design to dance styles. However, it is generally taken, especially in its singular form, to refer to fashions in clothing, and in this *Very Short Introduction* I will explore the ways in which fashion functions, as an industry, and how it connects to wider cultural, social, and economic issues. Fashion's emergence since the 1960s as a subject of serious academic debate has prompted its analysis as image, object, and text. Since then it has been examined from a number of important perspectives. The interdisciplinary nature of its study reflects its connection to historical, social, political, and economic contexts, for example, as well as to more specific issues, including gender, sexuality, ethnicity, and class.

Roland Barthes studied fashion in relation to the interplay of imagery and text in his semiotic analyses *The Fashion System* of 1967 and *The Language of Fashion*, which collected together texts from 1956 to 1969. Since the 1970s, cultural studies has become a platform from which to explore fashion and identity: Dick Hebdige's text *Subculture: The Meaning of Style* (1979), for example, showed the ways in which street fashions evolved in relation to youth cultures. In 1985, Elizabeth Wilson's book *Adorned in Dreams: Fashion and Modernity* represented an important assertion of fashion's cultural and social importance from a feminist perspective. Art history has been a significant methodology, which enables close analysis of the ways fashion interconnects with visual culture, as epitomized in the work of Anne Hollander and Aileen Ribeiro. A museum based approach was taken by Janet Arnold, for example, who made close studies of the cut and construction of clothing by looking at garments in museum collections. Various historical approaches have been important to examine the fashion industry's nature and relationship to specific contextual issues. This area includes Beverly Lemire's work from a business perspective, and my own work, and that of Christopher Breward, in relation to cultural history. Since the 1990s, scholars from the social sciences have become particularly interested in fashion: Daniel Miller's and Joanne Entwistle's work are important examples of this trend. Caroline Evans' impressively interdisciplinary work, which crosses between these approaches, is also very significant. Fashion's study in colleges and universities has been equally diverse. It has been focused in art schools, as the academic component of design courses, but has spread to inhabit departments from art history to anthropology, as well as specialist courses at under- and postgraduate levels.

This academic interest extends to the myriad museums that house important fashion collections including the Powerhouse Museum in Sydney, the Costume Institute at the Metropolitan Museum in New York, and the Kyoto Museum. Curatorial study of

fashion has produced numerous important exhibitions and the vast numbers of visitors who attend such displays testify to the widespread interest in fashion. Importantly, exhibitions provide an easily accessible connection between curators' specialist knowledge, current academic ideas and the central core of fashion, the garments themselves, and the images that help to create our ideas of what fashion is.

A vast, international fashion industry has developed since the Renaissance. Fashion is usually thought to have started in this period, as a product of developments in trade and finance, interest in individuality brought about by Humanist thought, and shifts in class structure that made visual display desirable, and attainable by a wider range of people. Dissemination of information about fashion, through engravings, travelling pedlars, letters, and, by the later 17th century, the development of fashion magazines, made fashion increasingly visible and desirable. As the fashion system developed, it grew to comprise apprenticeships, and later college courses, to educate new designers and craftspeople, manufacturing, whether by hand or later in a factory, of textile and fashion design, retailing, and a variety of promotional industries, from advertising to styling and catwalk show production. Fashion's pace began to speed up by the later 18th century, and by the time the Industrial Revolution was at its height in the second half of the 19th century had grown to encompass a range of different types of fashion. By this point, haute couture, an elite form of fashion, with garments fitted on to individual clients, had evolved in France. Couturiers were to crystallize the notion of the designer as the creator not just of handmade clothes, but also of the idea of what was fashionable at a particular time. Important early couturiers such as Lucile explored the possibilities of fashion shows to generate more publicity for her design house by presenting her elaborate designs on professional mannequins. Lucile also saw the potential of another important strand of fashion, the growing ready-to-wear trade, which had the potential to produce a

large number of clothes quickly and easily and make them available to a far wider audience. Lucile's trips to America, where she sold her designs, and even wrote popular fashion columns, underlined the interrelationship between couture styles and the development of fashionable readymade garments. Although Paris dominated ideals of high fashion, cities across the world produced their own designers and styles. By the late 20th century, fashion was truly globalized, with huge brands such as Esprit and Burberry sold across the world, and greater recognition of fashions that emanated from beyond the West.

Fashion is not merely clothes, nor is it just a collection of images. Rather, it is a vibrant form of visual and material culture that plays an important role in social and cultural life. It is a major economic force, amongst the top ten industries in developing countries. It shapes our bodies, and the way we look at other people's bodies. It can enable creative freedom to express alternative identities, or dictate what is deemed beautiful and acceptable. It raises important ethical and moral questions, and connects to fine art and popular culture. Although this *Very Short Introduction* focuses on womenswear, as the dominant field of fashion design, it also considers various examples of significant menswear. It will focus on the later stages of fashion's development, while referring to important precursors from the pre-19th-century period to show how fashion has evolved. It will consider Western fashion, as the dominant fashion industry, but equally will question this dominance and show how other fashion systems have evolved and overlapped with it. I will introduce the reader to the fashion industry's interconnected fields, show how fashion is designed, made, and sold, and examine the significant ways in which it links to our social and cultural lives.

Chapter 1
Designers

For Chanel's spring 2008 couture catwalk show, a huge replica
of the label's signature cardigan jacket was placed on a
revolving platform at the centre of the stage. Made from wood,
but painted concrete grey, this monumental 'jacket' towered
over the models, who emerged from its front opening, paraded
past the audience of fashion press, buyers, and celebrities,
pausing in front of its interlocked double 'C' logo, and then
disappeared inside this iconic emblem of Coco Chanel's legacy.
The models wore a simple palette, again reflecting the label's
heritage: graphic black and white was tempered with dove
greys and palest pinks. Outfits were developed from the tweed
cardigan jacket that literally and metaphorically dominates
Chanel, but this classic garment was made contemporary,
light and feminine, shredded into wispy fronds at its hem, or
fitted and sequined, worn with tiny curving skirts that drew on
the organic forms of seashells for their delicate silhouettes.
Both the show's staging and the clothes shown epitomized
the house's origins, in their combination of Coco Chanel's
love of chic skirt suits, glittering costume jewellery, and tiered
evening dresses, merged with current designer Karl Lagerfeld's
sharp eye for the contemporary.

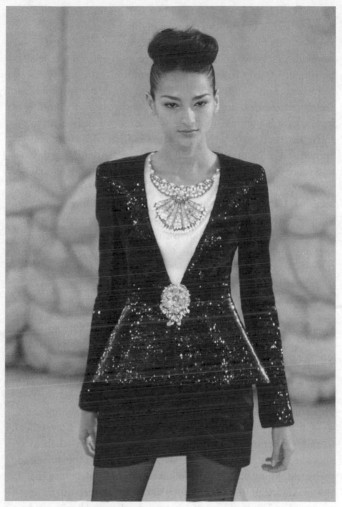

2. Karl Lagerfeld's 2008 version of the classic Chanel suit

Chanel's evolution as one of the most famous and influential couture houses of the 20th century highlights many of the key elements to successful fashion design, and exposes the relationships between design, culture, commerce, and, crucially, personality. Coco Chanel's emergence in the 1910s and 1920s as a prominent figure on society and fashion pages, her mythologized rise from nightclub singer to couturier, and gossip surrounding her lovers, gave her simple, modern styles an air of excitement and intrigue. Her designs were significant in their own right, and epitomized contemporary fashions for sleek, pared-down daywear, and more feminine, dramatic eveningwear. She asserted that women should dress plainly, like their maids in little black dresses, although Claude Baillén quotes Chanel as reminding women that 'simplicity doesn't mean poverty'. Her love of mixing real and costume jewellery and her borrowings from the male wardrobe became internationally famous. Coco Chanel's biography provided the publicity and interest necessary to distinguish her house, and dramatize her as a designer and personality. Importantly, her diversification into accessories, jewellery, and perfumes, and the sale of her designs to American buyers, brought the essence of her fashions to a far wider market than could afford haute couture, and secured her financial success.

In the 1980s, fashion commentator Ernestine Carter characterized Chanel's success as founded upon 'the magic of the self'. As important as Coco Chanel's undoubted design and styling skills were, it was her ability to market an idealized vision of herself, and to embody her own perfect customer, that made the label so appealing. Chanel designed herself, and then sold this image to the world. Many others have followed her example: since the 1980s, American designer Donna Karan has successfully projected an image of herself as a busy mother and businesswoman who has designed clothes for women like herself. In contrast, Donatella Versace is always photographed in high heels and ultra-glamorous, tight-fitting clothes, her jetset lifestyle mirrored in the jewel-coloured luxury of the Versace label's designs.

Karl Lagerfeld, Chanel's present designer, represents a variation on this theme; rather than embodying the lifestyle of his customers, his personal style denotes his status as a cultured aesthete. If Coco Chanel was a fashion icon to her followers, embodying a modernist ideal of chic, streamlined femininity in the early 20th century, then Lagerfeld is a Regency dandy remodelled for contemporary times. The key elements of his personal style have remained constant throughout his stewardship of Chanel: dark suits, long hair pulled back into a ponytail and at times powdered white. Combined with the constantly flicking black fan he used to carry, his image harks back to the ancien régime. This evokes the elite status of couture, and the consistency of Chanel style, while his involvement in various art and pop cultural projects maintains his profile at the forefront of fashion.

When Chanel died in 1971, the house lost its cachet and its sales and fashion credibility dwindled. In Lagerfeld's hands it has been revitalized. Since his arrival in 1983, he has designed collections for couture, ready-to-wear, and accessories that have balanced the need for a coherent signature, and the equally important desire for fashions that reflect and anticipate what women want to wear. Lagerfeld's experience in freelancing for various ready-to-wear labels, including Chloé and Fendi, had proved his design skills and his crucial ability to create clothes that set fashions, and flatter women's bodies. He merged high and popular culture references to maintain Chanel's relevance, and to invigorate its fashion status. His spring 2008 Chanel couture collection demonstrated this and showed his business acumen. While he kept older, loyal customers in mind with his variations on the cardigan jacket, the collection's tone was youthful, with girlish flounces and froths of light fabrics counterposed with its more sombre tones. Lagerfeld therefore looked towards the future to ensure Chanel's survival, encouraging new, younger clients to wear this iconic label.

Evolution of the couturier

Historically, most clothing was made at home, or fabrics and trimmings were bought from a range of shops and made up by local tailors and dressmakers. By the end of the 17th century, certain tailors, particularly in London's Savile Row, were establishing their names as the most accomplished and fashionable, with men travelling from other countries to have suits made for them by names such as Henry Poole. Although specific tailoring firms would be fashionable at particular times, menswear designers were not to achieve the status and kudos of their womenswear counterparts until the second half of the 20th century. The term 'tailor' evoked a collaborative practice, both in terms of the range of craftsmen involved in making suits, and the close discussions with clients that shaped the choice of fabric, style, and cut of the garments. In contrast, by the late 18th century, the creators of women's fashions had begun to evolve an individual aura. This reflected the greater scope for creativity and fantasy in womenswear. It was also dependent upon the distinct relationship that gradually developed between aristocratic fashion leaders and the people who made their clothes. While even the most noted tailors worked closely with their clients on the design of their clothes, women's dressmakers began to dictate styles.

Although fashion has remained an essentially collaborative process, in terms of the number of people involved in its production, it came to be associated with the idea of a single individual's design skills and fashion vision. The most famous early example of this shift was Rose Bertin, who created outfits and accessories for Marie Antoinette and a host of European and Russian aristocrats in the late 18th century. She was a *marchande des modes*, which meant she added trimmings to gowns. However, the *marchande des modes*' role began to change, in part as a response to Bertin's skill at creating a fashionable look. She drew

inspiration from contemporary events, crafting a headdress incorporating a hot air balloon in honour of the Montgolfier brothers' balloon flights in the 1780s, for example. She generated publicity with such creations, and although other *marchandes des modes*, including Madames Eloffe and Mouillard, were also famous at this time, it was Bertin who best expressed the ebullience of contemporary Parisian fashion.

In 1776, France replaced its guild system with new corporations, and raised the status of the *marchandes des modes*, allowing them to make dresses, rather than just trim them. Bertin was the first Master of their corporation, which increased her fashion prominence. She dressed the 'grande Pandora', a doll clothed in the latest fashions, which was sent to European towns and to the American colonies. It was one of the main ways to propagate fashions before the regular publication of fashion magazines. In this way, Bertin helped to disseminate Parisian fashion, and to assert its dominance of womenswear. Her development of a wide customer base and her close relationship with the French queen ensured her fashion status. Significantly, contemporary commentators noted with horror that Bertin behaved as though she was equal to her aristocratic clients. Her elevated status was another important shift that set the stage for the dictatorial ways of many designers. She was aware of her power and confident of the importance of her work, creating fashions, but also fashioning the image of her customers, who relied on her for their own status as fashion leaders. Indeed, her boutique, the Grand Mogul in Paris, was so successful that she opened a branch in London. Her innovative styling and witty references to both historical and contemporary events showed her design skills, as well as her awareness of the importance of generating publicity. She therefore became a precursor to the couturiers, who were to evolve their own status as dictators of fashion in the 19th century.

The French Revolution effected a temporary halt in information about Parisian fashions reaching the rest of the world.

However, once this was over, the luxury trades in France were quickly re-established, and various dressmakers began to distinguish themselves as the most fashionable. Louis Hyppolite Leroy defined the fashionable style of Empress Josephine and other women of the Napoleonic court, as well as a range of European royalty. In the 1830s, names such as Victorine became well known, raising themselves above the ranks of anonymous dressmakers. Leroy and Victorine, like Bertin before them, sought to create designs and set fashions, and to assert their own prominence, as well as that of their titled clientele. However, most dressmakers, even those with aristocratic customers, did not originate designs. Instead, they provided permutations of existing styles, adapted to suit the individual customer. Styles were copied from the most famous dressmaking establishments or from fashion plates.

However, alongside leading dressmakers, there was another aspect of the fashion industry that was also involved in the evolution of the idea of the fashion designer. Art historian Françoise Tetart Vittu has shown that some artists worked in ways that mirror freelance designers today, with dressmakers buying highly detailed drawings of fashions from them. These would then be used as templates for garments, and would even be sent to customers as samples. Advertisements for the dressmakers would be attached to the back of the illustrations, along with prices for the outfit shown. By the middle of the 19th century, artists such as Charles Pilatte advertised themselves as 'fashion and costume designers' and appeared in Paris directories of the time under a list of 'industrial designers'.

The idea of clothing needing to be designed by someone with fashion authority, and with particular skills in defining a silhouette, cut, and decoration, was evolving across the Western world. Each town would have its most fashionable dressmakers, and designs themselves were gaining commercial value as fashions began to change more rapidly along with the public's

desire for new styles. For the idea of the fashion designer to crystallize, there needed to be not only creative individuals ready to generate new fashions, but a growing demand for novelty and innovation. The 19th century saw the rise of the bourgeoisie and wealthy industrialists, whose newly found status was in part constructed through visual display, in their homes and, even more importantly, their clothes. Couture became a source of exclusivity and luxury for wider groups of women, with Americans amongst the most prolific customers in the second half of the century.

Added to this was the growth of fashion media, photography, and by the end of the century, film, which disseminated imagery of fashion more widely than ever before, and fuelled women's desire for more variety and quicker turnover of styles. As the huge growth in cities led to greater anonymity, fashion became a major way to formulate identity and to make social, cultural, and financial status visible. It was also a source of pleasure and sensuality, with Parisian couture at the apex of this realm of fantasy and luxury.

While 'industrial designers' supplied fashion designs to the wider dressmaking trades, it was the evolution of the couturier that was to establish the role and image of the fashion designer. Although Charles Frederick Worth, the most famous couturier of the 1850s, succeeded in part because of sound business practices, this side of his work was masked by the drama of his creations, and his persona as a creative artist whose fashion pronouncements were to be followed without question. An Englishman who had honed his skills in the dressmaking section of department stores, he was able to distinguish himself early on in his career in part because he was a man in a profession dominated by women. Indeed, in *All Year Round* in February 1863, Charles Dickens remarked with horror at the rise of the 'bearded milliner'. As a man, Worth could promote himself in ways that would be seen as inappropriate for a woman, and he could treat his female

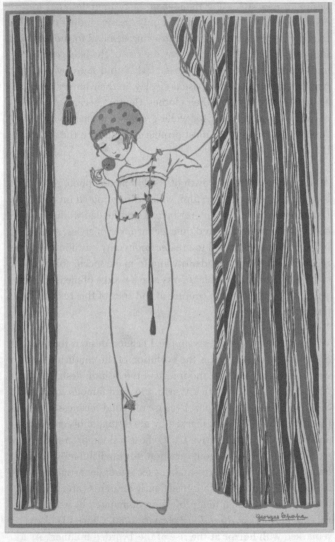

**3. Paul Poiret's delicate Empire line gown, drawn by Georges
Lepape in 1911**

clients differently, irrespective of their rank. His most famous designs comprised froths of ivory tulle, creating clouds around the wearer that would glimmer in candlelit ballrooms as the beading and sequins embroidered between the layers caught the light.

Other couturiers were also rising to prominence, often propelled to fame by their royal customers. In England, John Redfern responded to the changing role of women in the period by producing couture gowns based on men's suits, and sporty ensembles for yachting. In France, female couturiers such as Jeanne Paquin made garments that shaped women's bodies and epitomized the ideal of the Parisienne. Many customers came from America, as Paris continued to lead fashion. Fashion houses, partly to raise the status of the designer, and partly to provide a recognizable identity and personality to promote each label, asserted the idea of the couturier as an innovator and artist. Cecil Beaton described women in the Edwardian period who tried to keep the names of their dressmakers secret. Such women wanted to be credited for their own fashion sense and remain better known than their couturier. However, couture houses were already evolving their own recognizable styles, which conferred fashion status on the women who wore them.

In the first decades of the 20th century, designers such as Paul Poiret and Lucile became internationally famous. They dressed theatrical stars, aristocrats and the wealthy, and promoted their own identities as decadent socialites in their own right. Poiret was a fashion designer in the modern sense of the phrase. He was known for his signature luxurious style, and the radical, seasonally changing silhouettes he created. Georges Lepape's fashion illustration shows Poiret's famous Empire line silhouette of 1911, which broke away from the tightly corseted fashions of the Edwardian period. His lavishly embroidered gowns and opera coats were inspired by contemporary art and design, from modernism to the Ballets Russes, and the aura of his potent couture image was disseminated still further by sales of his own

perfume line. Poiret's contemporaries were equally adept at harnessing modern advertising and marketing methods to create the image of their fashion house. Most sold their designs to American wholesalers, for them to make up a strictly defined number of each model they had bought. This generated income for the couture houses, alongside money from the individually made garments that were the very definition of haute couture.

The interwar period was a high point for couture, when Madeleine Vionnet, Elsa Schiaparelli, Coco Chanel, and others defined the idea of modern femininity through their creations. Their success underlined the fact that fashion has long been one of the few arenas in which women could be successful as creators and entrepreneurs, heading their own businesses and providing work for countless other women in their couture studios. Indeed, couture is a collaborative venture, with big fashion houses comprising numerous studios each working on a different aspect of a design, for example tailoring or draping or decoration, including beading or feathers. Despite the number of people involved in the creation of each garment, the idea of the fashion designer has evolved in line with the idea of the artist as a creative individual. This is partly because design and innovation are the most valued aspects of fashion, since they are the basis for each collection and viewed as the most creative element of the process. Importantly, this focus on the individual is also a successful promotional tool, as it gives a focus for the identity of a fashion label, and quite literally, provides a 'face' for the design house.

Although not governed by the strict rules that apply to Parisian haute couture, other countries have developed their own couturiers and made-to-order industries. For example, in 1930s London, Norman Hartnell and Victor Stiebel asserted themselves as fashion designers rather than just court dressmakers, while in New York, Valentina evolved a dramatically simple style that drew on contemporary dance to create an American fashion identity, and in

the 1960s in Rome, Valentino promoted a distinctively Italian form of couture that relied on overtly feminine luxury.

In the post-war period, fabric and labour costs increased, making couture even more expensive. Designers such as Christian Dior revelled in excess, after the hardships of the 1940s, with their focus on the traditions of couture craftsmanship, and led a decade in which couture continued to dominate international fashion trends. Since the 1960s, despite the rise of throwaway youth fashions and the global fame of ready-to-wear designers, couture has maintained its visibility. Its significance has shifted, but certain couturiers, such as John Galliano at Dior, Alber Elbaz at Lanvin, and Lagerfeld at Chanel, are still able to set fashions that disseminate through all levels of the market. Despite a falling number of clients, ready-to-wear lines, accessories, perfumes, and a huge number of other licensed ranges place couture at the forefront of the huge global luxury market. Although there are fewer haute couture customers in Europe, other markets have periodically emerged. Oil wealth increased sales in the Middle East in the 1980s, as did the strong dollar and love of display in Reagan's America, while the enormous wealth generated in post-Communist Russia has provided more clients in the early 21st century. Combined with the prominence of celebrity culture and the rise of the red carpet dress, couturiers continue to produce seasonal collections. Even if these one-off designs do not make a profit themselves, the huge quantity of publicity they generate asserts the continued importance of the designer at the heart of the couture industry.

Evolution of the ready-to-wear designer

In her 1937 book *Clothes Line*, the British fashion journalist Alison Settle wrote that the interconnected nature of the Parisian haute couture industry was crucial to its success. Fabric, dress, and accessory designers and makers were in close contact with each other, and could respond to developments within each field.

Trends were therefore identified quickly and integrated into couturiers' collections, allowing Paris to maintain its position at the forefront of fashion. Settle was also impressed by how embedded fashion was within French culture, with people of all social classes interested in clothing and style. As Settle noted, couturiers 'forecast fashion by observing life', and this approach was particularly significant in the evolution of the ready-to-wear fashion designer. Couturiers realized that many women wanted to buy clothes that were not just in line with contemporary styles, but which were made by a fashionable name.

From the early 1930s, designers began to create less expensive collections, which could reach out to this wider audience. Lucien Lelong, for example, started his 'Lelong Édition' line, selling readymade dresses at a fraction of the cost of his couture collection. Couturiers continued to work on readymade clothes; for example, in the 1950s, Jacques Fath designed a successful line for American manufacturer Joseph Halpert. However, when Pierre Cardin launched a ready-to-wear collection at Parisian department store Printemps in 1959, he was briefly expelled from the Chambre Syndicale de la Haute Couture, which regulates the couture industry, for branching out in this way without seeking permission. At the same time, Cardin was exploring the potential market in the Far East, in his quest for global success. These moves, when considered in relation to his bold, modern style, were part of a shift in emphasis in French fashion, as couturiers strove to maintain their influence in response to the increasing success of ready-to-wear designers. In 1966, the launch of Yves Saint Laurent's Rive Gauche boutiques chimed with popular culture and recognized women's changing roles with trouser suits and vividly coloured separates. Saint Laurent showed that couturiers could set fashions through their ready-to-wear collections too. In a 1994 interview with Alison Rawsthorn, one customer, Susan Train, described his new line as 'so exciting. You could buy an entire wardrobe there: everything you needed.' However, the 1960s is generally viewed as a key moment when mass-produced,

youthful ready-to-wear began to lead fashion in a way it never had before. American designers such as Bonnie Cashin, British names, for example Mary Quant, and Italians, including Pucci, were all asserting their fashion influence at different levels of the market and shaping the way fashion was designed, sold, and worn.

While ready-to-wear clothes had been developing independently of Parisian haute couture since the 17th century, it was not until the 1920s that they were designed and marketed principally on their fashion values, rather than their price or quality. In Paris, this meant couturiers spent the following decades making agreements with department stores internationally to sell versions of their couture garments, as well as evolving their own lines. In America, manufacturers, including Townley, and stores such as Saks Fifth Avenue were quick to employ designers to work anonymously to develop fashion lines.

It was in the 1930s that these designers began to emerge from anonymous back rooms and have their names included on labels. In New York, Dorothy Shaver, vice-president of specialty store Lord & Taylor, began a series of campaigns promoting American ready-to-wear and made-to-order designers alongside each other. Window and in-store displays included photographs of named designers shown with their fashion collections, encouraging a cult of personality that had previously been reserved for couturiers. This was partly an attempt to encourage homegrown talent while the hardships of the Great Depression made trips to Paris to source fashions too costly. It was also symptomatic of fashion designers' need to group together in order to promote the status of their own fashion capitals. While Paris maintained its place at the heart of fashion, by the 1940s, in the absence of French influence during the war, New York had begun to assert its fashion status. Subsequently, cities across the world have followed the same process, investing in design education, holding their own fashion weeks to promote their designers' collections, and seeking to sell both domestically and internationally. The role of

the fashion designer is vital to this process, once again providing creative impetus combined with recognizable faces that could be used as the basis for promotional campaigns. In the 1980s, Antwerp and Tokyo each demonstrated their ability to develop distinctive fashion designers, with the rise of names such as Ann Demeulemeester and Dries Van Noten in Belgium, and Rei Kawakubo of Comme des Garçons and Yohji Yamamoto in Japan. By the early 21st century, China and India, amongst others, were also investing in their fashion industries and cultivating their own seasonal shows.

The way designers are trained influences their approach to creating a collection. For example, British art colleges emphasize the importance of research and individual creativity. This stress upon the artistic elements of the creative process produces designers, such as Alexander McQueen, who are inspired by history, fine art, and film. His collections have been staged on themed sets, with models writhing in a huge glass box, or sprayed by a mechanical paint jet as they turn slowly on a rotating platform. His models are styled as characters, part of a narrative that is told through clothes and setting. His cinematic approach was apparent in his spring 2008 collection, which was inspired by the 1968 film *They Shoot Horses Don't They?* This prompted a Depression-era dance marathon theme, choreographed by avant-garde dancer Michael Clark. Models slid across a dance floor, dressed in fluid tea dresses and worn denims, their skin glistening and eyes glazed as if they had been dancing for hours, half-carried, half-dragged by male dancers. McQueen's promotion of fashion as spectacle underpins the success of his label and testifies to his creative appeal.

In contrast, colleges in the United States tend to encourage designers to focus on creating clothes for a particular customer group and to keep business considerations and ease of manufacture at the forefront of their minds. They use industrial design as a model to promote an ideal of democratic design that

aims towards the greatest number of potential consumers. The work of designers such as Bonnie Cashin from the 1930s to 1980s is a good example of how this approach can lead to measured collections that aim to address women's clothing needs. Her designs looked streamlined, while demonstrating close attention to detail, with interesting buttons or belt buckles to enliven their plain silhouettes. In 1956, Cashin told writer Beryl Williams that she believed that 75% of a woman's wardrobe comprised 'timeless' pieces, and stated that 'all those clothes of mine were perfectly simple . . . they were simply the kind of clothes I liked to wear myself'. She designed lifestyle clothes for work, socializing, and leisure time, while promoting herself as the embodiment of her easy-to-wear styles. This type of design has come to characterize American fashion, but its simplicity can make it difficult to define a distinct image for a label. Between the late 1970s and late 1990s, Calvin Klein used controversial advertising campaigns to gain publicity for his clothing and perfume lines. Imagery such as the photograph of a teenage Kate Moss, nude and androgynous for Obsession in 1992, provided him with an edgy, contemporary image that belied the conservative styling of many of his designs.

While these designers have relied on the idea of the individual as fashion originator, many fashion houses employ whole teams of designers to produce their lines. For this reason, Belgian designer Martin Margiela refuses to give individual interviews, and avoids having his photograph taken. All correspondence and press releases are signed 'Maison Martin Margiela'. In 2001, in a faxed interview with fashion journalist Susannah Frankel on Maison Margiela's alternative approach to fashion, the choice to use non-professional models was explained as part of this overall strategy: 'We have nothing against professional or "top models" as individuals at all, we just feel that we prefer to focus on the clothes and not all that is put around them in and by the media.' His labels are blank or stamped with the number of the collection a garment comes from. This deflects attention from the individual

designer and suggests the collaborations necessary to make a fashion collection, while acting to distinguish his work. For other designers, the emphasis is placed more on their celebrity customers, who add a glamorous aura to their collections. In the early 21st century, American designer Zac Posen benefited from young Hollywood stars, including Natalie Portman, wearing his dresses on the red carpet. The coverage that stars receive at such events can boost sales for new designers, as well as established fashion houses, as shown by Julianne Moore's successful championing of Stefano Pilati's designs for Yves Saint Laurent.

Menswear designers have also risen to the fore during the 20th century, although they do not command the same level of attention as womenswear designers. Designs tend to focus on suiting or leisurewear, and menswear is perceived as lacking the spectacle and excitement attached to womenswear. However, designer names began to emerge in the 1960s, with, for example, Mr Fish in London and Nino Cerruti in Italy. Both exploited the more flamboyant designs of the decade to the full, with vibrant colours and pattern and unisex elements included in their designs. Michael Fish evolved his style while working within the elite environment of Savile Row, before opening his own boutique in 1966. Meanwhile, Cerruti's sleek designs evolved out of his family's fabric business, launching his first full menswear collection in 1967. Parisian couturiers also branched out into menswear design, including Yves Saint Laurent in 1974. In the 1980s, designers continued to explore the parameters of menswear design, focusing on adaptations of the traditional suit. Giorgio Armani stripped out its stiff underpinnings to create soft, unstructured jackets in wools and linens, while Vivienne Westwood tested the limits of gender boundaries in fashion, adding beading and embroidery to jackets or putting male models in skirts and leggings.

Since the 1990s, the rich colours and textures of Dries Van Noten's collections, and the innovative fabrics in Prada's designs, for

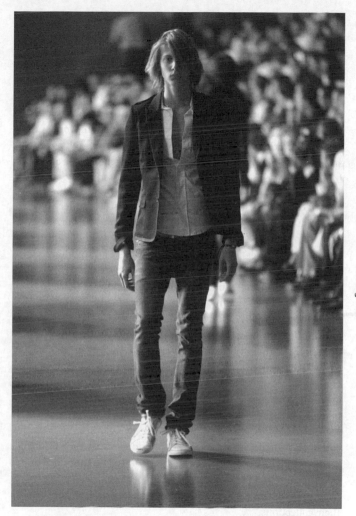

4. Hedi Slimane's highly influential skinny silhouette for spring 2005

example, have shown that menswear design can attract attention for subtle details. The growth of male grooming and fitness culture has added to interest in the field. In the early 21st century, designers such as Raf Simons, and especially Hedi Slimane, who designed for Dior Homme from 2000 to 2007, developed a skinny silhouette for men, which was very influential. Slimane's narrow trousers, monochrome palette, and tightly fitted jackets required a youthful physique that was androgynous and uncompromising. The speed with which celebrities and rock stars, as well as high street stores, adopted this look demonstrated the power and influence that confident menswear design could have.

One of the strongest reference points in menswear collections since the 1960s has been subcultural style. From the narrow suits worn by sixties Mods to the pastel leisurewear of eighties Casuals, street style balances individuality and group identity. It therefore appeals to many men's search for clothing that acts as a kind of uniform, while simultaneously allowing them to add their own personal touches. Members of subcultures in many ways design themselves through their style, by customizing garments or breaking mainstream rules about how clothing should be worn or combined. In the late 1970s, this DIY ethos was epitomized by Punks, who adorned their clothes with slogans and safety pins, ripping the fabric and creating their own individual interpretations of classic leather biker jackets and T-shirts. While since the mid-1990s Japanese teenagers of both sexes have made their own clothes, combining them with elements of traditional dress such as obi sashes to create a wide variety of styles, united by their love of exaggeration and fantasy. By referring to these practices, fashion designers can add a seemingly rebellious edge to their collections.

Indeed, since the 1990s, fashion consumers have increasingly sought to individualize their look by customizing garments and mixing designer, high street, and vintage

5. Japanese street fashion brings together references to East and West, old and new

clothes. This enables them to act as designers themselves, if not always of individual garments, then of the look and image they wish to convey. The idea of the 'fashion victim' of the 1980s who wore complete outfits by one designer has led many wearers in reaction to seek to express their own creativity through the way they adapt and style themselves, rather than relying on designers to construct an image for them. This approach mimics both subcultural style and the work of professional stylists. It reflects a developing knowingness amongst certain consumers, and their wish to be both part of fashion yet above its dictates. While the 20th century undoubtedly saw the establishment of the designer name as the guiding force in fashion, this has not gone unchallenged. The 1980s was perhaps the apex of the cult of the designer, and while many labels are still revered, they must now compete both with a wider number of global rivals and with many consumers' desire to design themselves, rather than unquestioningly obey fashion trends.

Chapter 2
Art

Andy Warhol's *Diamond Dust Shoes* of 1981 shows a cluttered array of bright, jewel-coloured women's pumps set against an inky-black background. Based on a photographic screen print, the shoes are shot from above, the viewer seemingly looking down on a wardrobe floor, crowded with odd shoes. A vertiginous tangerine stiletto presses up next to a more demure, tomato-red rounded toe, while a brocaded midnight-blue evening slipper lies next to a salmon-pink, bow-adorned court shoe. The colours are overlaid onto the image and produce a cartoonish pastiche of the multitude of styles and shapes of shoes available.

The picture is cropped to give the impression that the pile of shoes is limitless, glimpses of the pointed tip of a lilac boot, for example, peek in at the edge of the frame. The image is carefully composed; despite the apparent jumble, each shoe is artfully displayed, with just enough inner labels visible to reinforce their high fashion status. It evokes the fashion image and the shoe shop, and thus refers to the combination of visual and literal consumption so fundamental to fashion. Warhol's painting is slick with the shine of polymer paint, an effect enhanced by the fact that the whole surface of the image is scattered with 'diamond dust', which glitters and dazzles the viewer as it catches

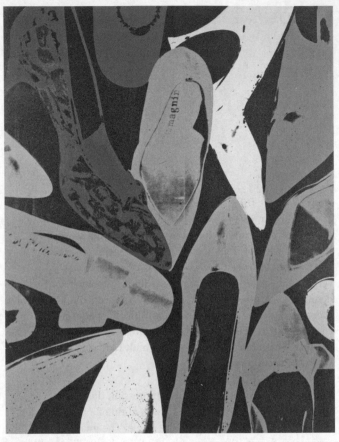

6. Andy Warhol's *Diamond Dust Shoes* of 1981 shows the glamour
and seduction of footwear design

the light. Its shimmering surface makes explicit reference to
fashion's glamour and ability to transform the mundane.

In the late 1950s, Warhol had worked as a commercial artist, with
clients including I. Miller shoes. His drawings for them were

sinuous and light, graphically evoking shoes' seductive appeal. His alliance to commerce and love of popular culture meant that fashion was a perfect subject for him. It featured in his screen prints and other artworks, and he continually used clothing and accessories, including his famous silver wigs, to alter and play with his own identity. In the 1960s, he opened a boutique, Paraphenalia, selling a mix of fashionable labels such as Betsey Johnson and Foale and Tuffin. Paraphenalia's launch included a performance by the Velvet Underground, and therefore united the varied strands of Warhol's entrepreneurial artworks. He understood the alliance between fashion, art, music, and popular culture that was crystallized during this decade. The marriage of avant-garde pop music with throwaway, experimental clothes that relied on brightly coloured metals, plastics, and clashing prints did not merely express the creative excitement of the period, it helped to define its parameters. For Warhol, there was no hierarchy of art or design forms. Fashion was not condemned for its commercial imperative, or its transience. Instead, these inherent qualities were flaunted in his work, as part of his fascination with the fast pace of contemporary life. Thus, the dazzling surface of *Diamond Dust Shoes* celebrated fashion's focus on outer appearance and spectacle, while his boutique brought attention to the commercial transactions and consumerist drive at the heart of fashion, and indeed much of the contemporary art market. In Warhol's art, fashion's supposed flaws of ephemerality and materialism become comments on the culture that spawned it. For Warhol, elements of mass culture and high-end luxury could coexist, in the same way that they did in fashion magazines or Hollywood films. In his work, multiples and one-offs were given equal status, and he moved easily from one medium to another, fascinated as much by the possibilities of film as of screen printing or graphic design. Rather than feeling this limited his work, or that commerce should be excluded from art for it to be legitimate, Warhol embraced contradictions. In his 1977 book *The Philosophy of Andy Warhol (From A to B and Back Again)*, he wrote of the blurred boundaries that drove his art:

Business art is the step that comes after Art. I started as a
commercial artist, and now I want to finish as a business artist. After
I did the thing called 'art' or whatever it's called, I went into business
art. I wanted to be an Art Businessman or a Business Artist. Being
good in business is the most fascinating kind of art.

Since the mid-19th century, fashion had increased in pace, reached
out to a wider audience, embraced industrial processes, and used
spectacular methods to sell its wares. Art also went through this
cycle of change; art markets grew to embrace the middle classes,
mechanical reproduction altered ideas of exclusivity, and
institutional and private galleries re-thought the way artworks
were displayed and sold. There also existed a crossover in
thematic concerns between the two disciplines, from issues of
identity and morality, to concerns over the way the artist or
designer was perceived within the wider culture, and a focus on
representation of and play with the body.

Fashion is occasionally cast as art, but this is problematic. Some
designers have appropriated aspects of art practice in their own
work, but they remain within the structure of the fashion industry
and use these borrowed methods to explore the nature of fashion
itself. When, for example, in their early career, Viktor and Rolf
decided just to stage fashion shows rather than produce any
saleable clothes, their designs became one-offs, rare pieces that
existed only as comments on the role of the show within the
fashion system, rather than wearable garments. However, their
work remained within the context of the fashion world, discussed
and reviewed by fashion journalists. It seemed like evolving
advertising campaigns for the collections they later showed, which
were put into production. Their work also served to underline
the differences between types of designers. Viktor and Rolf's
interpretation of fashion incorporated a fascination with the role
of the show, and its potential to test the boundaries of spectacle
and display. They slip between art, theatre, and film in the staging
of their collections. For autumn/winter 2000, the designers slowly

dressed a single model in layer upon layer of garments, until she wore the whole collection. This commented on the process of fitting clothes on the body, which lies at the core of traditional fashion design. The exaggerated scale of the final clothes she was swathed in seemed to turn her into an immobile doll, a living mannequin, and the plaything of the designers. In 2002/3's show, all the clothes were bright cobalt, and acted like the blue screen used to shoot special effects in television and cinema. Film was projected across the models' bodies, which made their figures disappear and seem to flicker as images hovered across their surface.

In Viktor and Rolf's designs and presentations, artistic methods are used to comment on the practice of fashion, but this does not necessarily turn their fashion into art. Their work is shown in the context of the international fashion weeks, it is directed to a fashion audience, and addresses the way clothing and body interact. Even when they were not putting their clothing into production, they followed the fashion seasons, and importantly, they adhered to the fundamental elements of fashion: fabric and body.

Fashion is sometimes compared to art in order to give it greater validity, depth, and purpose. However, this perhaps reveals more about Western concern that fashion lacks these qualities than it does about fashion's actual significance. A Balenciaga dress from the 1950s, when displayed in a pristine glass case in a gallery, may appear like a work of art. However, it does not need to be described as such in order to convey its value or the skill that went into its creation. Like other design forms, such as architecture, fashion has its own particular concerns that prevent it from ever being purely art, craft, or industrial design. It is, rather, a three-dimensional design form that incorporates elements of all these approaches. It is Balenciaga's exacting eye for precise form that brings balance and drama to the drape and structure of the fabric, combined with the craft skill of his atelier

workers, that turns it into an exceptional piece of fashion clothing. It does not need to be called art in order to validate its status, and this term ignores the reason, beyond his desire to create and test the parameters of fashion design, that Balenciaga's dresses were brought into being: to clothe a woman, and, ultimately, to sell more designs. This should not be seen to diminish his achievement, but to help to understand the way he has worked to exploit these 'limitations' to create fashions that can inspire the viewer as much as the wearer.

Fashion should be understood on its own terms, and this makes its interactions with other aspects of art and culture more interesting. It opens up the way art, design, and commerce connect and overlap in some practitioners' work. Indeed, one of the things that makes fashion so fascinating, and for some, so problematic, is the fact that it continually appropriates, reconfigures, and tests the boundaries of these definitions. Thus, fashion can highlight tensions concerning what is valued in a culture. Designers and artists as diverse as Andy Warhol and Viktor and Rolf produced work that played upon cultural contradictions and attitudes. In fashion's case, focus on body and cloth, and the fact that it is, usually, designed to be worn and sold, distinguishes it from fine art. However, this does not prevent fashion from being meaningful, and the art world's continued fascination with fashion underlines its cultural significance.

Portraiture and identity

Perhaps the most obvious connection between fashion and art is the role clothing has played within portrait painting. In the 16th century, the Reformation's impact in Northern Europe led to a decline in commissions for religious paintings, and artists therefore turned to other subject matter. Since the Renaissance, humanist interest in the individual added to many members of the nobility's desire to be portrayed by artists. The growth of portraiture established a relationship between artist and sitter,

and between fashion and representation. Holbein's paintings of the royal court and nobility of Northern Europe explored the visual effects that can be conveyed in paint, and suggested the tactile differences between, for example, satin, velvet, and wool. Holbein's precision is apparent in the detailed drawings that he undertook in preparation for his portraits. Jewellery was sketched in all its intricacy, and the delicate layers of muslin, linen, and stiffening that women's headdresses comprised were explored with as much care as sitters' faces and expressions. Holbein understood the role fashionable dress played in conveying his clients' wealth and power, as well as their gender and status. These attributes were made manifest in his paintings, and turned into mementoes not just of past clothing styles, but of fashion's role in constructing an identity that could be read and understood by contemporaries. His portraits of Henry VIII portray the period's visual excess, with padded layers of silk and brocade to add size and grandeur to his figure. Gold and jewelled trimmings and accessories increased this effect, and fabrics were slashed to reveal further lavish garments beneath. His portraits of women were equally rich in detail. Even his sombre 1538 painting of Christina of Denmark wearing mourning dress revealed the fabric's richness. The soft shine of her long black satin gown is emphasized by the light falling on its deep folds and full, gathered shoulders. This is contrasted with the tawny red-brown fur that lines the gown, and the supple pale leather of her gloves. Holbein's compositions, like those of artists across Europe at the time, placed focus on the sitters' faces, while also giving great emphasis to displaying their clothing's splendour.

This spectacle of fabric and jewellery is present in the work of artists from Titian to Hilliard. Even when, as in the portrait of Christina of Denmark, the dress is restrained and undecorated, the lushness of the materials plays a major role in establishing the sitter's status. The significance of this display would have been easily comprehensible to contemporaries. Textiles were hugely expensive, and therefore greatly valued. The ability to

purchase and wear an array of cloth of gold and silk velvets asserted the sitter's wealth. Glimpses of white shirts and smocks, worn beneath the layers of outer garments, further reinforced sitters' standing. Cleanliness was a mark of status, and servants were needed to keep linens laundered and white, and ruffs starched and properly pressed into their complicated shape.

Art did not merely serve to advertise royal and noble status; it also displayed character, taste, and the sitter's relationship to fashion. While artists such as Holbein strove to paint contemporary fashions accurately, as part of the overall realist approach of his work, others used greater artistic licence. During the 17th century, Van Dyck and others often showed sitters in draped fabrics that curved around the body in impossible ways. They framed the body in allegorical dress, intended to evoke Greek muses or goddesses. Women were swathed in pastel satins that seemed to fly around the body and float over the surface of the skin. Men were shown in outfits that were part reality, part fancy dress. While Van Dyck also painted fashionable dress, he frequently imposed his own unifying taste for light-reflecting surfaces and uninterrupted planes of colour. Thus, art mediated fashion, it was not just a record of what was worn and how, but of ideals of beauty, luxury, and taste.

Art's relationship to fashion became more complex as fashions began to change seasonally during the 18th century, and some artists became uneasy about the effect of this on the status of their work. Some portraitists, such as Joshua Reynolds, wanted to strive for longevity and create a painting that would transcend its time. Fashion seemed to hamper these ambitions; it pulled a painting back into the time when it was created. As styles changed yearly, if not seasonally, portraits were precisely datable. While for Van Dyck and his sitters classicized clothing was part of a playful interest in fancy dress, for Reynolds it was a serious attempt to break from fashion and propose an alternative way to guarantee the relevance of portraits for posterity. He therefore

strove to erase fashion from his art, painting sitters in imagined swathes of fabric to relate the figure to classical drapery seen in ancient statuary. Fashion's power to shape how body and beauty are perceived disrupted Reynolds' intentions. Although the dress he often painted was plain, so was much of fashion in the last quarter of the 18th century, as was the long, narrow silhouette that he favoured. The sitter's desire to be seen as modish also hampered his classicizing eye. Female clients persisted in wearing towering, powdered wigs, often topped with plumes of feathers. Their faces were also powdered white, with cheeks fashionably pinked.

This combination of the sitter's wish to be seen as fashionable and the artist's difficulty in breaking away from the dominant visual ideal of the day meant that it was almost impossible to paint a portrait that did not betray its date. In her book *Seeing through Clothes*, Anne Hollander proposed that:

> in civilised Western life the clothed figure looks more persuasive and comprehensible in art than it does in reality. Since this is so, the way clothes strike the eye comes to be mediated by current visual assumptions made in pictures of dressed people.

Hollander contends that it is not just the clothed body that is 'learnt' through its representation in art. She also argued that artists' vision is trained by contemporary fashion, and that even when a nude body is painted, the shape of the body and the way it is presented is tempered by prevailing fashionable ideals. The small, high breasts and low stomachs of Cranach's nudes of the 15th century, Rubens' full-bodied *Three Graces* of the 1630s, and Goya's clothed and nude *Maja* of the early 19th century all bear witness to the impact of the fashionable silhouette on the way the body is portrayed. In each case, the shape of the clothed body, re-formed by corsetry, padding, and overgarments, is imposed on the naked figure. Thus, the relationship between portraiture and fashion is deeply

embedded, and demonstrates the interconnected nature of visual culture at any given time.

This interrelationship was to become more explicit in the 19th century, with artists such as Cézanne, Degas, and Monet using fashion plates as templates for their female figures and the clothes they wore. Since many people see fashion through imagery, whether paintings, drawings, fashion plates, or later photographs, the viewer, like the artist, is coached to understand the clothed bodies she sees around her in terms of these representations. Indeed, Aileen Ribeiro has taken this idea further to suggest the materialism involved in commissioning and purchasing art was part of the same consumer culture that saw the growth of the fashion industry in the second half of the 19th century, and the comparably huge amounts charged by leading portraitists and couturiers such as Charles Frederick Worth. Ribeiro cites as evidence of this close alliance Margaret Oliphant's observation in her book *Dress* of 1878 that 'there is now a class who dress after pictures and when they buy a gown ask "will it paint?"'.

Perhaps the most compelling example of this blurred line between fashion and its representation is the collection of over four hundred photographs taken by Pierre-Louis Pierson between 1856 and 1895 of Virginia Verasis, the Comtesse de Castiglione. She took an active role in the way she was dressed, styled, and posed. She therefore took on the role of artist herself, controlling both her presentation through fashion and her representation in the photographs. Her elaborately decorated dresses of the mid-19th century act like fashion photographs, while going beyond the remit of fashion imagery to construct an individual's relationship to dress. Castiglione was aware that she was giving a performance in each image, and staged herself within a suitable environment, whether a studio setting or on a balcony. She demonstrated the power of 'self-fashioning', using dress to define and construct the way she was perceived and her body displayed. For her, the interconnections between fashion and art were a powerful tool to

7. Countess Castiglione created her own image in numerous photographs of the mid-19th century

allow experimentation with various identities, since, as Pierre Apraxine and Xavier Demarge have argued:

> Castiglione's use of her own body – the primary source of her art – and the way in which she orchestrated her public appearances [presaged]...such contemporary developments as body art and performance art.

Fashion's significant role in visual culture, and the inextricable link between actual garments and their representation in art and magazines, meant artists tended to be ambiguous about its power. While portraitists including Winterhalter and John Singer Sargent used their sitters' fashionable dress to shape compositions and suggest the status and character of their sitters, others, most notably the Pre-Raphaelites, rejected fashion's pervasive hold on ideals of beauty, style, and taste. By the 1870s, an Aesthetic dress movement had emerged which sought to offer an alternative to fashion's restrictive definitions of the body, in particular the role of corsetry in moulding women's bodies. Men and women turned instead to looser-fitting historicized styles. However, Aesthetic dress itself became a fashion, although it crystallized the idea that artists and those interested in fine art might dress in an alternative, anti-fashion style. While they might refuse contemporary trends, their studied indifference to their dress is implicit recognition of fashion's role in shaping how they are perceived, and the power of dress in fashioning identity.

Collaborations and representations

During the 20th century, there were numerous cross-fertilizations and collaborations between art and fashion. Haute couture's developing aesthetic sensibilities combined advanced craft skills with individual designers' vision and pressure to create a strong business practice to ensure prolonged success. Couturiers sought to establish their design houses' identities in relation to contemporary beauty ideals and this necessarily saw them look

to modern art as a visual prompt and inspiration. In Paul Poiret's hands, this meant an exploration of notions of the exotic, and, like Matisse, he travelled to Morocco to find alternatives to Western approaches to colour and form. Poiret's fantasy of rich planes of colour, draped harem trousers, and loose tunics contributed to an ideal of femininity that had been increasingly apparent in both popular and elite culture since the later 19th century. Poiret and his wife Denise were photographed in orientalized robes, reclining on sofas at their infamous 'One Thousand and Second Night' party. When viewed in conjunction with Poiret's designs, these images promoted his couture house as luxurious and decadent. Importantly, they also positioned him as uncompromisingly modern, despite the historical references that underpinned many of his garments. Poiret was aware that he needed to cultivate an image of himself that drew on notions of the artist as an individual creative force, while also producing designs that could successfully be sold abroad, particularly to America. His work, in common with other couturiers, had to balance between the demands of the one-off outfit for a single client, which had more in common with the authenticity of fine art, and the commercial imperatives of creating designs that could be sold to and copied by manufacturers internationally. Although Poiret strove to maintain an artistic image, and drew upon such influences as the Ballets Russes, he also undertook promotional tours to Czechoslovakia and America to increase awareness of his designs amongst a wider audience.

Nancy Troy has written of this delicate relationship between fine art practice and haute couture in the first decades of the 20th century. She identified shifts in each discipline that were a response to the increasingly blurred line between popular and elite culture, and therefore also to distinctions between the 'authentic' original and the reproduction. As she noted, designers and artists tried 'to explore, control, and channel (though not necessarily to stave off) the supposedly corrupting influence of commerce and commodity culture'.

Couturiers had varied approaches both to managing these issues and to incorporating influences from contemporary art into their designs. Poiret's work flourished under the influence of vibrant, often clashing colour and emphasis on theatrical self-presentation. It is therefore unsurprising that when he made direct collaborations with artists, it was in textile designs by Matisse and Dufy, for example. Such connections between leading avant-garde artists and their equivalents within fashion seem both natural and mutually beneficial. Each side was able to experiment, exploring new ways to think about and present their ideas. Each potentially benefited by the association with another form of cutting-edge contemporary culture to combine the visual with the material. Elsa Schiaparelli staged more extensive collaborations, most famously through her work with Salvador Dali and Jean Cocteau. These connections produced clothes which gave life to Surrealist tenets, including Dali's 'lobster' decorated dress. This brought the movement's love of juxtapositions and complex relationship to notions of femininity into the physical realm, with Schiaparelli's wearers turning their bodies into statements on art, culture, and sexuality.

For Madeleine Vionnet, an interest in contemporary art's preoccupations was seen in her technical explorations of the three-dimensional planes of a garment, inspired by the fragmented representational style of Italian Futurism. Her work with Ernesto Thayaht showed a dynamic union between his spatial experiments and her concern for the relationship between body and fabric. His fashion plates of her designs made this link explicit, rendering her designs as Futurist ideals of femininity. The models' bodies and clothes were fractured to show not just their three dimensions, but to suggest their lines of movement and their intrinsic modernity.

If Poiret's association with art was through his desire for luxury and freedom in design expression, then Vionnet's was part of a search for new methods to address the body and the way it was

represented. Both couturiers were also widely copied, despite the intricacy of their designs. Their concern about manufacturers' profligate use of their work exposed the contradictions inherent within modern fashion (and, indeed, art). As Troy has shown, what was at stake was not just ideals of artistic integrity; copying could also undermine their businesses and jeopardize their profits.

Given art and fashion's growing push into the commercial world, it was inevitable that artists and designers would look to mass-produced ready-to-wear as another site for collaboration. Such projects brought tensions between the two disciplines, and their relationship to industry and finance to the fore. This could be through political belief in the power of art to change the lives of the masses, as seen in Russian Constructivist Vavara Stepanova's designs of the 1920s. While most of her contemporaries shunned fashion for its ephemerality, she felt that, despite its problematic associations with capitalism and business, it was bound to become more rational, in the same way that she perceived 'daily life' in the Soviet Union to be. She therefore broke with her fellow Constructivists to state that:

> It would be a mistake to think that fashion could be eliminated or that it is an unnecessary profit-making adjunct. Fashion presents, in a readily understandable way, the complex set of lines and forms predominant in a particular time period – the external attributes of the epoch.

Fashion's ability to connect more directly with the wider community has made it an ideal medium for artists who want to connect their work to the popular sphere. This might follow in the traditions established by Poiret at the start of the 20th century, as seen in the witty prints designed by Picasso, amongst others, for a series of American textile designs in the 1950s, and used by designers including Claire McCardell. In the early 1980s, Vivienne Westwood's work with graffiti artist Keith Haring was closer in spirit to Schiaparelli's collaborations with artists. In

each case, their joint work represented a common interest and intent, in Westwood and Haring's example in street culture and challenging accepted ideas of the body, which translated into clothes decorated with an artist's drawings.

The commercial and consumer ethic at the heart of many collaborations between fashion and art became more manifest in the later 20th and early 21st centuries. While Rei Kawakubo's rigorous intellectual approach to fashion is without question, it is interesting to see how successfully she has negotiated the potentially fraught relationships between artistic endeavour, fashion, and consumption. Peter Wollen has compared Japanese designers' approach to these interconnections to that of Wiener Werkstätte artists, who sought to design clothes as part of a 'total environment'. This environment includes, perhaps most significantly, the retail space, which for Comme des Garçons has become a temple for Kawakubo's design aesthetic and a site of continuing collaborations. Leading architects, including Future Systems, designed boutiques for her in New York, Tokyo, and Paris. Her interior displays ape iconic modernist works, such as the apparently haphazard design of her Warsaw guerrilla store, which made reference to Bauhaus designer Herbert Bayer's ground-breaking presentation of identical chairs fixed to the walls in the German section of the Society of French Interior Designers annual exhibition of 1930.

Kawakubo, like other designers including Agnès B, has taken this ambiguity between commercial retail space and gallery further, to hold exhibitions in her boutiques. In Comme des Garçons' Tokyo store, displays have included Cindy Sherman's photography, which itself appropriates fashion practices. Such exhibitions are not new, for example New York department store Lord & Taylor held a show on Art Deco in the late 1920s, while Selfridges in London showed Henry Moore's work in the 1930s. However, by the end of the century connections were more complex and links between the two areas more firmly embedded, especially

within the work of artists and designers dealing with the body and identity.

At the start of the 21st century, the relationship between art and fashion remains as fraught as it is revealing of cultural values and subconscious desires. The lines between fashion in art and art in fashion became hazier, but so did the distinctions between the spaces in which each was shown. Shops, galleries, and museums employed similar approaches to display and foregrounded consumption of art, fashion, and the cultural kudos attached to each. For example, Louis Vuitton sponsored a party for the launch of its spring/summer 2008 collection of handbags decorated with prints by Richard Prince. The party was held at the Guggenheim Museum in New York, on the last night of Prince's exhibition there, drawing comment from some areas of the press on the problems of commercial sponsorship and the status of fashion in the gallery. This demonstrated how art and fashion, although inextricably linked, can both gain and lose from comparisons made when they are brought into close proximity.

Miuccia Prada has been very active in examining these cross currents. In 1993, she established the Fondazione Prada to support and promote art. She also commissioned architects, including Rem Koolhaas, to design iconic 'epicentre' stores for her, which would provide a space for art exhibitions to be held alongside her clothing on the shop floor. This included huge photographic prints by Andreas Gursky at her store in Soho, New York. The fact that Gursky's work has frequently critiqued consumer culture adds an ironic edge to Prada's display of his photographs. Thus, architect, artist, and designer are presented as knowing and self-aware, creating fashion, art, and buildings, while simultaneously commenting on these practices.

Miuccia Prada's complicated relationship with fashion and art was best expressed in her exhibition *Waist Down: Miuccia Prada, Art and Creativity*, which examined the evolution of skirt design

8. The 2006 touring exhibition *Waist Down* included creative displays of Prada skirts

within her collections. Designed by Koolhaas' architectural team, the show travelled internationally, held in venues such as the Peace Hotel in Shanghai in 2005. The exhibition used experimental display methods; skirts hung from the ceiling on special mechanized hangers which spun them round, or were spread out and encased in plastic to look like decorative jellyfish. Prada's financial acumen and global success enabled such innovative design to be possible, and her connections within the art and design world facilitated its realization.

However, Prada herself seemed intrigued by the ambiguity of these connections, and yet conflicted about how this linked fashion and

art. When the exhibition travelled to her New York boutique in 2006, she commented to journalist Carl Swanson that 'shops are where art used to be', but went on to demur over the status of her exhibition and the other works displayed at her epicentre store, stating that:

> It's a place for experimentation. But it's not by chance that the exhibition is in the store. Because it started with the idea of putting more things to discuss, mainly about my work, in the store. It's like an explanation of the work. It's not at all anything connected with art. It's just to make the store more interesting.

This contradiction lies at the heart of fashion's relationship with art. Collaborations between artists and fashion designers can produce interesting results, but there can be discomfort from both sides about how such work is perceived. As important aspects of visual culture, fashion and art both represent and construct ideas about, for example, the body, beauty, and identity. Nevertheless, art's commercial side is revealed by its closeness to fashion, and fashion can seem to be using art to provide it with gravitas. What is revealed by such crossover projects is that each medium has the potential to be both consumerist and conceptual, meaningful and about surface display. It is these similarities that bring fashion and art together, and which add interesting tensions to their relationship.

Chapter 3
Industry

The 1954 British short film *Birth of a Dress*, directed by Dennis Shand, begins with a shot of London store windows filled with fashionable ready-to-wear dresses. As the camera pans across the shiny surface of the windows, a voiceover comments on the diversity of fashions available to British women, and the role of haute couture as inspiration for readymade designs. The frame then closes in on a specific cocktail dress; fitted close to the figure with a deep flounce down one side, it expresses the verve of 1950s eveningwear. The dress, we are told, was designed by noted London couturier Michael Sherard, and then adapted to become a mass-produced garment, available to 'the ordinary woman on the street'. The film then details this process. The fashion media usually work to cover up the industrial background from which clothing emerges, but *Birth of a Dress* positively celebrates the wonders of British manufacturing and design, which have gone into the dress's production. Sponsored by the Gas Council and Cepea Fabrics, it unmasks the series of factories where the cotton for the dress is bleached and prepared. The viewer is taken inside the textile mills' artists' offices, where the fabric print is designed, in this case a typically British floral of a rose sketched in charcoal. The etching process that transfers the print to a roller, the science laboratory that develops the aniline dyes (a by-product of the gas industry), and the factory printing mile after mile of the fabric are

9. A still from the 1954 film *Birth of a Dress*, which tracks the design and production process of a mass-market dress range

all proudly displayed as evidence of the North of England's expertise and invention.

The focus then shifts to Michael Sherard's refined Mayfair salon, where, inspired by the fabric, he fashions an original evening dress. From there, a Northampton factory's ready-to-wear designers reinterpret the dress for the mass-production process. Simplifying the design, they produce a stylish gown in three colour ways that is presented in a fashion show to international buyers. Thus, the viewer is reminded of the varied stages necessary in the production of the fashionable clothes she wears. The design is connected to British success in couture and mass fashion, and the viewer is prompted to see these clothes as 'allied to all that is newest in industrial research and scientific development'. The film is a post-war promotion of industry, Britishness, and burgeoning consumerism. Its focus on the process that goes into fashion's creation was unusual, since it connected all aspects

of an industry which is normally presented only in fragments: as a complete garment, a designer's idea, or an object to aspire to.

As *Birth of a Dress* shows, the fashion business comprises a series of interconnecting industries. At one end of the spectrum these focus on manufacturing, and at the other on the promotion and dissemination of the latest trends. While producers contend with technology, labour, and managing the commerce of design, journalists, catwalk show producers, marketers, and stylists turn fashion into spectacle and make trends comprehensible to the consumer. Clothing is transformed by these industries, literally through the manufacturing process, and metaphorically through magazines and photographs. The fashion industry therefore produces not just garments, but also a rich visual and material culture that creates meaning, pleasure, and desire.

In their article on the industry's development, Andrew Godley, Anne Kershen, and Raphael Schapiro have shown that fashion is predicated on change. It is inherently unstable and seasonal, and each facet of the industry therefore searches for ways to temper this unpredictability. Forecasting trade shows project several years ahead to set trends in textiles, and themes that can guide and inspire fashion producers. Brands employ experienced designers, whose instinct for evolving trends is balanced with signature pieces to create successful collections. Fashion show producers and stylists then present collections in the most enticing way to develop the label's image, gain press coverage, and encourage stores to place orders. Store buyers rely on their awareness of their customer profile and retail image to purchase the outfits most likely to sell well, and reinforce the fashion credibility of the retailer they represent. Finally, the fashion media from style magazines to high-fashion titles advertise and editorialize fashion to seduce and entice their readers.

Fashion's development since the mid-14th century has been based upon technical and industrial breakthroughs, tempered by

reliance on long-standing traditions of small-scale, labour-intensive methods that retain the flexibility necessary to meet the challenges of seasonal demands. Importantly, the fashion industry is also driven by consumer demand. During the 18th century, there was a shift from annual changes in textile designs and fashion styles to seasonal changes. Wearers would adapt their clothing in line with seasonal trends, to create new effects through trimmings and accessories. While the wealthy could afford expensive bespoke fashions, as Beverley Lemire has noted, those lower down the social scale could combine second-hand and, from the 17th century, readymade garments.

Clearly, fashion went beyond a process of simple emulation, either of aristocrats, or later of French couture styles. While it should not be assumed that everyone did, or for that matter could, follow fashion, consumer demand is a significant factor in its advance as an industry. Since the Renaissance, aspirations to individuality, aesthetic sensibilities, and the pleasure taken in clothing, whether tactile or visual, all played a part. The industry therefore generates local, national, and international fashions, with makers and promoters catering to diverse desires and needs. From the regional fashions of young, 18th-century English apprentices, eager to distinguish themselves through the trimmings on their clothes, or the elaborate velvets of 16th-century Florentine dignitaries, fashion involved a complex chain of traders, distributors, and promoters.

The evolution of the fashion industry

The Renaissance industry thrived on a global trade in fabrics, with free cross-pollination from East and West. Garments were made up using gradually more sophisticated methods, improved in the 16th century by Spanish tailoring books that enabled better fit. Wars and trade led to styles spreading across the Western world in the later 15th century, the Burgundian court's etiolated styles

dominated, while dark Spanish fashions spread in the following century. Such fashions were part of consumers' desire for luxury and display, which was formalized in the 17th century by Louis XIV's regulation of the French textile trade. While this consolidated a centuries-old textile manufacturing and global trading network, the French monarch's efforts also recognized fashion's role in shaping not just a nation's identity, but also its economic wealth. This imperative later saw the formation in 1868 of what would become the Chambre Syndicale de la Haute Couture, to police the haute couture industry in Paris. At the other end of the scale, newly industrializing countries continue to build up their own fashion and clothing industries, as witnessed by Mexico's upgrading of its production capacity during the 1990s.

The 17th century saw growing recognition and consolidation of rich fabrics in Lyons, luxury trades in Paris, and tailoring in London, based on small-scale making-up of garments, frequently carried out in little workshops or households that focused on traditional craft skills. While this encouraged wealthy locals' and tourists' consumption of fashions, it was the early attempts to make readymade clothes that would lead to the fashion industry's wider impact, in terms of dressing more people, increasing financial gains, and, ultimately, in its status as a major international economic and cultural force.

Military needs drove significant advances in the readymade industry. The Thirty Years War (1618–48) saw the development of a large standing army, uniformed by both military and contracted-out workshops, a process that increased during the 18th century and later Napoleonic Wars. Early readymade garments focused on nondescript dress, clothing sailors in 'slops', the wide-legged breeches they commonly wore, and basic garments for slaves. While this was not part of the fashion industry *per se*, it set the necessary prerequisites for the ready-to-wear industry which was subsequently to emerge.

America's development as a nation played a crucial role. In 1812, the United States Army Clothing Establishment opened in Philadelphia, one of the earliest readymade manufacturers. Along with the huge demand for uniforms during the Civil War, and Levi Strauss' Gold Rush-driven denim business, an industry was emerging based upon greater standardization of methods and garment sizing. Claudia Kidwell identifies a parallel change in attitude towards readymade clothing in the later 19th century. It was no longer seen as denoting lack of money and status. As urbanization increased, city workers and dwellers wanted affordable clothing, 'which looked in no way appreciably different from the mainstream fashion'. The greater visibility of fashions in the city, and people's corresponding desire for individuality amidst the crowds, was another motivating force for the industry.

Demand was interconnected with innovations. The spinning jenny (c. 1764) speeded up textile production, and the jacquard loom (1801) increased the complexity of fabric designs. However, it was the development of a rational sizing system that allowed effective mass clothing production, and the growth of the broader fashion industry from the mid-19th century. By 1847, for example, Philippe Perrot states that there were 233 ready-to-wear manufacturers in Paris, employing 7,000 people, while in Britain, the 1851 census showed that the clothing trade was second only to domestic service as the largest employer of women. By this point, readymade womenswear was also developing and, as with early menswear examples, it focused on easy-fitting garments such as mantles.

Singer's introduction of the sewing machine in 1851 is sometimes credited with revolutionizing ready-to-wear. However, it was not until the 1879 invention of an oscillating shuttle running on steam or gas that a marked difference was made in the speed and ease of manufacturing. Andrew Godley has written that a skilled tailor could make 35 stitches per minute. However, by 1880

powered sewing machines could produce 2,000 stitches, and in 1900 this figure had increased to 4,000 stitches per minute. Further innovations, in cutting and pressing techniques, for example, reduced costs to manufacturer and consumer, as well as production times.

Immigrants fleeing the pogroms in Russia in the 1880s added further impetus to the British and American readymade industries, and Jewish tailors and entrepreneurs played a fundamental role in the fashion industry's development. Elias Moses, for example, staked his claim in advertising as 'the first House in London . . . that established the system of NEW CLOTHING READY-MADE', further asserting that 'tailoring is as rapid in these days as railway travelling'. Moses' association of his own trade's speeded-up methods with faster modes of travel is apposite. Not only did the train system quicken trade and distribution, it opened up the potential for travel, spreading fashions across and between classes as well as countries.

Travel and holiday clothes, sports and leisure fashions, from black veil 'uglies' to shield women from seaside sunshine in the mid-century to the steady rise of the more relaxed lounge suit for men, powered the growth of readymade fashion. In the last quarter of the 19th century, women's entry into white-collar work necessitated new styles appropriate to the public sphere. 'Tailormades', the prototype of women's suits, developed in the 1880s. Worn with blouses, they represented yet another option in the burgeoning array of fashions opening up to both sexes at the end of the 19th century. Indeed, the American 'shirtwaist' blouse became a huge craze in the early 1890s, and showed the close alliance between consumer demand and supplier innovation that motored the fashion industry.

If the 18th century had witnessed a growth in Western consumer culture that sparked people's desire for fashion, then the 19th century turned this love of novelty and sensuality into a frenzy

of spectacle and commerce that spread across the globe. Inventors patented a quick succession of mass-produced crinolines, corsets, and bustles to reshape women's bodies using the latest technologies; rubber and celluloid provided collars and cuffs to young men eager to adopt the white-linen elegance of a gentleman cheaply and easily, and aniline dyes meant fabrics brazenly combined fashion with scientific innovation.

At the same time as this acceleration within the readymade industry, couture was adopting increasingly astute business methods. Promotional techniques, especially fashion shows, employed to great effect by, for example, Lucile and Worth, as well as leading department stores, disseminated elite visions of fashion style. These generated publicity at all levels of the market, and provided templates for manufacturers eager to adapt the latest trends to their own price point. American buyers were particularly keen to take advantage of the commercial potential of couture's aura of authenticity. They paid to attend shows, purchasing a pre-agreed number of garments, from which they could produce a limited number of copies. As in the 17th century, Paris was a synonym for luxury, the city's name exploited in advertising and editorial copy, and attached to shop and brand names internationally as a marker of fashion credibility. Paris embodied elegance and Old World luxury, and it also provided a model for other cities' clothing industries, as each sought to formulate its own saleable signature for the domestic and international market.

By the end of the 19th century, fashion's growth as a driving force within the clothing industry brought stylish clothes to a wider cross-section of people. While fashion enabled people to construct new identities, its under-side was the exploitation of workers, usually female and frequently immigrant. The sweatshop was a dark shadow haunting the industry's burgeoning modernity. From the 1860s onwards, reports shocked both governments and public with tales of the cramped conditions,

long hours, and poor wages that kept retail prices down and enabled deadlines to be met. Debate over the ethics of production led to greater unionization and, in the early 20th century, laws concerning minimum wages. While it is the clothing industry, with its focus on mass-produced, standardized garments, which has been guiltiest in its exploitation of labour, fashion continues to cause controversy. The Victorian image of emaciated young women sewing couture gowns has been replaced by exposés of brands using child labour in Asia and South America.

While fashion manufacturers had traditionally needed to be close to the market, to respond quickly to consumer demand for particular trends, better information systems meant making up could be subcontracted to increasingly far-flung sites. As the 20th century wore on, technology enabled sales figures for each garment style to be collated from shops' individual cash registers to enable orders to be made rapidly. Improved travel and distribution speeded up this process further, aiding internationally successful brands such as Sweden's H&M, and Spain's Zara. Such companies could reproduce, and in some instances pre-empt, high-fashion trends by responding both to designer collections and close observation of emerging trends on the street. It also meant that it was harder to ensure working conditions, leading to accusations against high-street brands such as Gap.

By the 1930s, the structure for the contemporary fashion industry had already been established. As the century wore on, it would become known as 'Fast Fashion', as it came to supersede the industry's previous seasonal timetable with regular supplies of new garments sent out to high-street retailers. The boom years of the 1920s were pivotal to establishing the foundations of this system. The decade saw greater investment and international communication, as well as increasing evidence that fashion, rather than quality or function, could be used to sell products from clothing to cars. As the Depression set in, cutbacks led to a focus on streamlining industrial practices, building domestic

markets, and seeking out new global regions to target, with Parisian couturiers and American ready-to-wear manufacturers both identifying South America as an important potential source of new customers.

The post-war period saw further consolidation of markets as well as domestic industries. American backing and business know-how aided the Italians and Japanese to develop their industries with a balance between fashion-led garments and wardrobe basics. Indeed, so important is this combination that Teri Agins identified it as crucial to a label's business survival. She asserted that American designer Isaac Mizrahi had to close his eponymous business in 1998, because he had focused entirely on fashion garments and ignored the need for classics.

Once again, this demonstrates the fashion industry's volatility, and designers' and manufacturers' need to factor in ways to increase and stabilize their market share. This can be seen in couturiers' establishment of licensing deals and ready-to-wear lines, and in the late 20th century, ready-to-wear label diffusion lines, such as Junior Gaultier and DKNY. These collections play upon the designer's aura, already established in their main lines, to widen their customer base with more affordable and usually more basic garments.

The need for outside investment and other means to financial assurance were tackled over the course of the 20th century. Burton's menswear manufactured and retailed its own designs, allowing a close relationship between demand and supply to be nurtured, and enabling the company to go public in 1929. From the late 1950s, French fashion labels were floated on the stock exchange. Since the 1980s, luxury giants, such as Louis Vuitton Möet Hennessey, whose portfolio includes Marc Jacobs, Louis Vuitton, Givenchy, Kenzo, and Emilio Pucci, ensured fashion credibility by grouping together younger labels with established houses, while protecting against losses by spreading

profits across a wide range of wine, perfume, watches, and fashion brands.

However, there is still a significant segment of the fashion industry that continues to work on the same small-scale, labour-intensive model which has survived for centuries. This is epitomized by the studio-workshops mainly focused in London's East End, where young designers such as Gareth Pugh, Christopher Kane, and Marios Schwab employ a tiny number of assistants to enable them to produce their collections. In a tradition set by British designers since the 1960s, the strong fashion content of their work attracts press interest and spreads their influence globally.

The development of fashion promotion and dissemination

The fashion media and promotions industry has developed in tandem with manufacturing and design, disseminating information on new fashions, and constructing ideals of fashion through imagery and text. While press coverage can undoubtedly boost designers such as Pugh, Kane, and Schwab, it can also undermine longer-term development. If young designers gain too much notoriety very early in their careers, before they have gained sufficient financial backing and manufacturing capability to fulfil orders, it can be hard for them to develop their businesses. However, press coverage is viewed as crucial to building a profile and, ultimately, to finding economic investment from a reliable backer. This contradictory situation has particularly plagued London Fashion Week, where art schools such as Central Saint Martins School of Art and Design regularly produce talented designers, but lack of infrastructure and government investment leaves them vulnerable.

In the second half of the 20th century, a cycle of seasonal international fashion shows came to dominate the industry. These

provided a platform for designers and manufacturers to display their collections as they wished them to be seen, rather than through the filter of magazine coverage. Fashion shows brought together buyers, whether from international stores or, in the case of couture, wealthy individual clients, and, as they developed, members of the press and photographers. From tiny showings in couture salons in the late 19th century, the catwalk show evolved its own visual language, comprising the models' movements and gestures, lighting and music accompaniments, and increasingly elaborate performances designed to convey each label's signature and vision.

Until the 1990s what was seen in these shows was filtered to the public through other media, whether newspapers, magazines, or later television channels such as Fashion TV. However, in the late 20th century, the Internet provided the general public with access to unedited shows, sometimes broadcast simultaneously on the designer's website. This immediacy has the potential to alter the balance of power between designers and manufacturers, the fashion media, retailers, and potential consumers. It brings an unmediated version of the designers' work to customers, who can demand items seen on the catwalks, which have not necessarily been picked up in magazines or by store buyers.

The international network of print, broadcast, and online media, reliant upon dramatic imagery to create fashion meaning, has evolved over centuries. During the Renaissance, trade and travellers, whether from local towns or abroad, would bring news of fashions. Caricatures mocked and celebrated fashions in equal measure. Leading dressmakers contrived to spread trends by sending out dolls dressed in the latest formal and informal styles. Letters provided an informal means to communicate information on new styles. Indeed, Jane Austen's correspondence with her sister Cassandra contains more fashion information than her novels do, detailing new trimmings on hats and new dresses purchased. This more anecdotal spread of fashions

continues in online blogs and is mirrored in the intimate style of smaller magazines, such as *Cheap Date* which focuses on vintage and DIY fashions.

By the 17th century, more formal methods evolved, including irregular fashion magazines, which took their cue from earlier costume books that showed the clothing of different countries. However, it was not until the 1770s that the first regular fashion magazine appeared. *The Lady's Magazine* set in train a whole industry of fashion journalism and image-making. What is perhaps most striking is how the format of such magazines has remained a template into the 21st century. Fashion magazines of the 18th and 19th centuries combined gossipy social events coverage, which detailed society figures' outfits, advice on beauty and style, fiction, and news from Paris's leading couturiers and dressmakers. Fashion magazines contained a powerful combination of didactic articles and sisterly advice on appropriate fashions, beauty, and behaviour. They constructed ideals of femininity, whether strongly moralizing visions of dutiful domesticity, as seen in the *Englishwoman's Domestic Magazine* with its inclusion of advice on housework and paper patterns for dressmaking, in the mid-19th century, or avant-garde challenges to sexual identity as seen in *The Face* in the mid-1980s.

From early on, magazines had close ties with fashion houses and manufacturers, through advertising and, more insidiously, through promotional links. In the 1870s, *Myra's Journal of Dress and Fashion*, for example, pioneered the advertorial, bringing together advertising and editorial content, featuring articles written by Madame Marie Goubaud, as well as advertising, imagery, and editorial coverage of her fashion house. This relationship grew in the 20th century. In the 1930s, Eleanor Lambert was one of the first to apply public relations techniques to fashion, recognizing the possibilities of multiple types of promotion. Thus, press representatives lobby to have labels included in editorial text and imagery, adding the fashion kudos

of the magazine to validate existing coverage in advertising. Lambert also encouraged film stars she represented to wear items by her stable of designers. In the 1950s, she sent sportswear designer Claire McCardell's new sunglasses range to Joan Crawford, in the knowledge that a photograph of Crawford wearing McCardell's designs would endorse the designer's work, while raising the star's fashion status.

Such cross-fertilization underpins the fashion industry. In the late 19th century, London's leading couturiers, such as Lucile, provided gowns for leading actresses to wear on stage, gaining free publicity and increasing the visibility of their wares. This practice continued, with designers creating costumes for films, whether in the form of iconic couture gowns by Givenchy for Audrey Hepburn in *Breakfast at Tiffany's* in 1961, or the cartoonish, sci-fi excess of Jean-Paul Gaultier's costumes for *The Fifth Element* in 1997. Crucially, actors and celebrities wore fashions during their 'private' life that helped to promote the idea that a particular designer's work connected intimately to their lives. Global coverage of events such as the Academy Awards ceremony provoked designers to compete to lend stars their gowns. While magazines, including *Hello*, followed in the footsteps of earlier Hollywood fan magazines to blur distinctions further between public and private by setting up shoots that show celebrities at home, listing the sources of everything they wear.

This interdependence between different strands of fashion and allied industries has been criticized as creating uniform ideas of acceptable identities. While this may be true to an extent, since the dominant image is undoubtedly slim, white, and youthful, fashion has simultaneously tested boundaries. Fashion and style magazines are part of the culture that spawns them, and therefore reflect wider attitudes towards race, class, and gender. Their role in representing what is new, and the fact that they can attract leading writers and image-makers, also means that they can suggest new identities and create a pleasurable escape from the

everyday. In the 1930s, American *Vogue* promoted the idea of the dynamic, modern woman, mixing more practical advice on what to wear to work with dramatic photo-shoots of aviatrixes, which suggested freedom and excitement. In the 1960s, British publication *Man About Town* brought together lifestyle advice for its male readers with imagery of smart suiting, photographed against stark urban exteriors. In Russian *Vogue* in the late 1990s, couture luxury and excess became a dreamscape from which to forget economic crisis.

Each publication formed its own style, to entice its audience and provide them with a marker of their own fashionable status. In the early 20th century, *The Queen* represented elegant, elite style; 1930s' *Harper's Bazaar*, under the editorship of Carmel Snow and art directed by Alexey Brodovich, created a magazine of high fashion, and dramatically paced pages of modernist elegance through its combination of strong text, imagery, and graphics; while *A Magazine*, produced in Antwerp since the 1990s, brought in avant-garde designers such as Martin Margiela to 'curate' each issue. Trade publications provide the analogue to the fantasy of much newspaper and magazine coverage, but are equally important in connecting fashion's disparate elements. The 19th-century publication *The Tailor and Cutter: A Trade Journal and Index of Fashion* provided practical information and technical discussion. Since the 1990s, websites, most significantly WGSN.com, have pooled information from global offices on trends predicted by international consultancies with coverage of what is happening on the streets of cities across the world, to enable the fashion industry to have instant access to emerging trends and developments.

The collages of image and text, body and clothing, editorial and advertising that fashion magazines created produced a space that readers could escape into. They constructed a realm of visual consumption, where even the feel of their pages, whether the glossy sheen of *Elle* or the textured inserts of *Another Magazine*,

contribute to a multi-sensory experience. Although they are ephemeral, they are documents of contemporary culture and society, and unite the commercial imperatives of the fashion industry with its intangible role in global visual culture. Not only do they report fashions, for many people they *are* fashion. The meanings that illustration and photography add to garments in some cases transform them into fashion. Between the everyday reality of clothing and the vision created through an illustrator's interpretation or the alchemy of a fashion shoot, layers of new ideas are brought to bear. These tap into contemporary mores, but frequently go far beyond what already exists to suggest heightened reality or surrealist narratives.

In this early 19th-century fashion plate, the illustrator simplified the lines of his sketch, echoing the purity of the fashionable silhouette. By showing the main figures in back view, focus is given

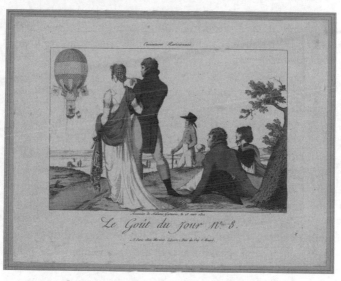

10. An 1802 fashion plate that shows the classicized fashions of the period

to the antique referenced drapery of the woman's dress, which is emphasized by the sweep of her rich red shawl. The shrunken tails of the man's coat are also stressed, set against the classically inspired 'nudity' of his flesh-toned pantaloons. Other fashion details, from the men's modish sideburns, to the seated woman's little scarlet hat, are set within the illustration's narrative. Fashion plates added mood and context to clothes, enhancing the raw information of simple illustrations that acted more as a template to show a dressmaker or tailor when ordering an outfit. The environment created a feeling of relaxed elegance, and connects clothing to wider fashions, in this case contemporary fascination with hot air balloons.

Fashion photography, which developed from the mid-19th century, performed a similar function, with the added element of showing clothing on real bodies. If production seeks to counterbalance fashion's unpredictable nature, then fashion imagery celebrates its ambiguities. Representation has played a central role in fashion's formulation, showing how styles might look on the body, and cataloguing the movements and gestures associated with particular garments.

This 1947 image by American photographer Toni Frissell shows how simple, everyday clothes can be transformed through representation. Rather than showing this tennis outfit in its usual courtside setting, Frissell places the model against a dramatic mountainous landscape. Natural lighting makes its bright white fabric glow, the crisp silhouette sharpened by sunshine. The model remains an anonymous identifying figure for the viewer. She turns away to look at the view, her pose emphasizing her athletic figure, but not far removed from a natural gesture. The balcony's curve connects her to streamlined modern architecture, and situates her in an environment speaking of both natural and manmade luxury. The fashion editor's choice of model, and styling of the shoot, with clean plimsolls and ankle socks, simple hair grip, and casually discarded cardigan, add to the idea of nonchalant ease projected by

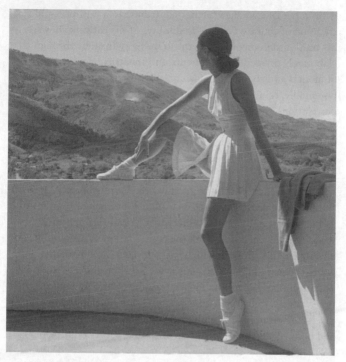

11. Toni Frissell's 1947 fashion photograph of a model in tennis dress set against a dramatic landscape

Frissell's staging and composition. Thus, ready-to-wear garments are given a gloss of fashionable grandeur they might otherwise lack.

The interconnecting industries that intercede between makers and consumers therefore create various points at which 'fashion' appears. These are incremental and cumulative. John Galliano's fashion training, experience, and intuition mean that his initial sketches contain future fashions, which are then amplified through the process of their evolution. The skilled craftspeople he works

with in the Dior ateliers further contribute to a centuries-old tradition of couture fashion credibility. At his catwalk shows, his fashion statement is brought to industry insiders through elaborately dressed environments and theatrical deployment of models and styling. The fashion press then reinforces and, potentially, reinterprets Galliano's fashion vision through written descriptions of key trends, connecting his work to that of his peers. Advertising and editorial photographs, retail and window displays, all act to validate his work as fashion, and suggest ways to imagine how it might be worn.

It is hard to single out the point at which clothing becomes fashion. In the case of couturiers such as Galliano, or earlier examples such as Balenciaga in the mid-20th century, it was through their working practice, but also via the constellation of promotions and advertisements through which their designs were mediated. For ready-to-wear and high-street stores' lines since the 1930s, it has been a similar mix of established fashion credibility built up over time, validation by the media, and an intangible ability to express diverse inspirations through dress in a way that connects clothing and body ideals to other aspects of contemporary culture.

Chapter 4
Shopping

In 2007, Comme des Garçons opened a new 'guerrilla store' in Warsaw. Scheduled to remain there for just one year, it was part of a programme of similar 'pop-up' shops by the label; the first was in East Berlin in 2004, followed by similarly transitory boutiques in Barcelona and Singapore. Each had its own character, in keeping with its environment. In Warsaw, the shell of an old Soviet-era fruit and vegetable shop remained intact, with green tiling, patchy plasterwork, and traces of ripped-out fittings on the rough walls. This aesthetic was extended into the 'display cabinets', really Soviet furniture, installed to house the label's range. Cabinets clung haphazardly to the walls; drawers spilled out, lopsided and half open to expose shiny perfume bottles; broken chairs cascaded from the ceiling with shoes balanced precariously on their battered seats; clothes were hung on bare metal rails; and twists of wire hung from light fittings and curled on the floor, half hidden under the stacks of fittings.

The effect was of an abandoned storeroom, with clothes and accessories left behind in the shopkeeper's rush to leave. This atmosphere was symbolic of its geographical and historical context, with communism abandoned in former Soviet bloc countries, to be replaced by capitalism. This has led to a shift from buying what was needed, or rather what was available, to shopping

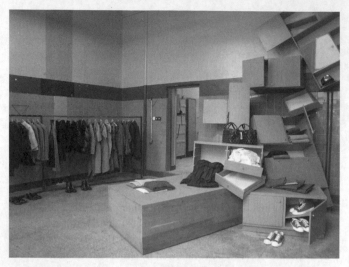

12. The interior of Comme des Garçons' 2008 guerrilla store in Warsaw is designed to look like a modernist furniture exhibition

for what is desired and aspired to, from a wide choice of goods. The rawness of the shop also chimed with the nature of guerrilla stores, which suddenly take over an urban space. Indeed, this was the label's third incarnation in Warsaw, the first had appeared in 2005 in a derelict passageway under a bridge.

Although they might seem unplanned, such shops are part of Comme des Garçons' strategy to remain at the forefront of fashion retailing. Some of the stores remain open for only a few days, others a year; none are advertised, other than through emails to existing customers, perhaps a few posters in the local area, and, crucially, through word of mouth. These processes mimic the effects of a subculture, reaching out to opinion-makers within an inner circle already aware of the label's status in the fashion industry as pioneers of avant-garde style and design. The guerrilla store creates an atmosphere of exclusivity, intrigue, and excitement around its products. It promotes the feeling that its visitors

68

have privileged knowledge, and that they are taking part in a semi-covert event by shopping there. It therefore plays into the key elements of early 21st-century high-fashion consumerism, by emphasizing desire, lifestyle, and identity. As such, the store, again like street cultures, suggests individuality yet membership of a group. It advocates shopping as an experience, in this case akin to visiting a small art gallery. Importantly, it builds the brand in a manner that is in keeping with its intellectual ethos. It apparently rejects the excesses and decadence of much fashion advertising and retailing, while remaining a shrewd marketing device to target its core audience, as well as luring in the curious passer-by.

Since the 1980s, Rei Kawakubo, the designer behind Comme des Garçons, has launched a series of innovative shops. The spare, minimal spaces of her early boutiques drew upon the aesthetics of traditional kimono shops, with garments folded on shelves. This was combined with a reverential air produced by the limited number of items on display, making shoppers focus on details and packaging. Her peers, as well as high-street brands such as Gap and Benetton, mimicked this approach, with wooden floors, plain white walls, stacks of sweaters piled on shelves, and carefully positioned clothes rails that emphasized space and clean lines.

Dover Street Market in London opened in 2004 by Kawakubo and her husband Adrian Joffe took a different approach, with carefully presented fashion and design labels shown in separate spaces across the building. On one floor, a changing room is housed in an oversized gilded birdcage, on another clothes are grouped with plants and garden accessories. Kawakubo's conception of Dover Street Market is as a place that is flexible and varied; she states on its website that:

> I want to create a kind of market where various creators from various fields gather together and encounter each other in an ongoing atmosphere of beautiful chaos: the mixing up and

coming together of different kindred souls who all share a
strong personal vision.

The affect is of a contemporary version of a 19th-century
bazaar, populated by a changing array of exclusive fashion lines
and eclectic objects.

Alongside Comme des Garçons' more permanent boutiques,
such enterprises stress the importance of variety and flexibility in
modern retailing. In a saturated market, designers and fashion
labels of all kinds must distinguish their identity to build a
strong customer base. While Comme des Garçons represents the
cutting edge of this enterprise, its methods hark back to earlier
predecessors, from 19th-century department store entrepreneurs
who understood the need to create spectacle around their goods,
to early 20th-century couturiers, who designed their salons as
intimate sensual spaces that mirrored the style of their clothes.

The development of retailing

During the Renaissance, fabrics and trimmings were, as they had
been for centuries, bought from markets and a range of itinerant
pedlars. Lace, ribbons, and other decorative items would be
taken around the countryside, or sold wholesale to local stores.
Larger villages might have a draper's shop, which sold wools and
other materials, while towns might also have a milliner's, which
would sell the finest silks and wools. Local dressmakers and
cobblers would make up clothes and accessories, and buying
garments could therefore be a lengthy process, as the elements of
an outfit were bought from various shops and then made up by
craftspeople. Purchasing patterns were different in each country.
In England, people would often travel to a nearby town or city
to buy more fashionable clothes. However, the fragmented politics
and geography of Italy meant greater distinction between regions,
and therefore a wider range of shops in each village.

A global trade in textiles had been established for millennia, with international routes crossing Asia and the Middle East into Europe. Huge fairs were held to buy and sell fabrics to merchants and pedlars who would travel to, for example, Bruges or Geneva, or later Leipzig, where fairs were held three times a year, or to Brigg market in Leeds. During the 17th century, the English and Dutch East India Companies (EIC) improved trade links with Asia. By the mid-18th century, cotton from India, for example, became an everyday fabric. It was fashionable and, more significantly, it was cheap and washable, and therefore brought greater levels of cleanliness to people of all classes. Such goods could be transported across the globe because of improved shipping. There was also an increasing demand for fashionable textiles, as more people wanted to be stylish and respectable, conforming to contemporary ideals of appearance and behaviour. The EIC fed people's desire for new and changing textile designs, importing silks, cottons, and calicoes. Merchants spread new fashions by encouraging fashion leaders to wear their latest goods to stylish social events, which would then be reported in fashion magazines. Woodruff D. Smith has described how the EIC then commissioned Indian craftspeople to create more of the most successful designs, selling them on across Europe as the fashion spread out from Paris. As Daniel Roche has noted in relation to changes in dress in France, by the end of the 18th century, there was in general a far wider range of consumer goods available, 'but everything that related to the expression of appearances, both social and private, increases still more'.

Textiles and clothing were relatively expensive, given to household servants as part of their wages, passed down through families, and sold on through a chain of used clothing shops and markets until they fell into rags or were turned into paper. In the 18th century, with better agricultural practices and distribution of wealth, more people wanted to buy fashionable clothes, at the very least for Sunday best. Shopkeepers began to take more time over the display and presentation of their wares and in their approach to customers. By the 1780s, plate glass windows led to enticing

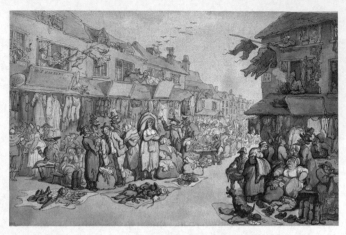

13. London street markets have traded in second-hand clothes for centuries

displays and interior displays were beginning to be more sophisticated. Fashionable shopping was already shaping the geography of cities. In London, Covent Garden had become the first fashionable suburb, with Inigo Jones' piazza housing various drapers' and milliners', which had moved west after the Great Fire of 1666. In Paris, the Palais Royal had been remodelled to provide perhaps the first purpose-built shopping centre, with rows of little shops and cafés around the perimeter of its gardens. Advertising and marketing were also developing. Handbills boasted of a particular shop's range of readymade garments or rich selection of fabrics; fashion magazines gave detailed descriptions and illustrations of the latest modes, and entrepreneurial manufacturers and salesmen encouraged fashion leaders to be seen wearing their goods. Since the Renaissance, shopping had developed hand in hand with a growing sense of personal identity. Fashionable dress provided the means to express this visually, and knowing where and how to shop for fashion was key to achieving this. Novelists such as Tobias Smollet satirized people's attempts to

dress attractively, fashionably, and, frequently, above their station, conscious of the growing consumer culture that was to flourish in the following century.

The growth of shopping

In the early 1800s, small specialist shops continued to be important, but it was the emergence of larger establishments that began to group together a wider range of goods and services, which was to herald a new era in shopping. Aristide Boucicaut opened his Bon Marché in Paris in 1838, which by 1852 had evolved into a department store. It brought together fabrics, haberdashery, and other fashionable products, and introduced a strong social element to shopping by including a restaurant. Boucicaut developed various customer services, which added to the sense of a change in relationship between shop workers and customers, and between customers and the way they used a shop. His prices were fixed, and marked on all goods, which eliminated the need to haggle, and he also allowed refunds and exchanges. The Bon Marché was one of a number of early department stores, including Kendel Milne in Manchester, which had evolved from a bazaar in 1831, and A. T. Stewart in New York, which gradually changed from a small draper's in 1823 to hold the dominant position in the city's main fashion shopping area on Broadway by 1863. These stores evolved increasingly sophisticated sales techniques. Shoppers were encouraged to browse, following the carefully designed routes through the shop floors, visiting the cafés and restaurants there, or stopping to watch the entertainments that were provided. For the first time, shopping became a leisurely pursuit, focused upon spending time and, it was hoped, money, in a fashionable, secure environment.

Women were the main targets for the department stores, and were enticed into these elaborate buildings by carefully organized window displays which emphasized the play of light on fine fabrics

and the rich colours and textures of their stock. Previously, it had been impossible for middle- and upper-class women to go shopping alone. Even with an accompanying maid or footman, certain streets were out of bounds at particular times of the day. Bond Street in London, for example, was a focus for shops for gentlemen, and it was improper for ladies to go there during the afternoons. These careful rules of etiquette were eroded by department stores, which encouraged women to socialize and browse, in what Edward Filene, the owner of a store in Boston, is quoted by Susan Porter Benson as calling an 'Adamless Eden'. Not only did this give women greater freedom, it also shaped them as consumers. Erika Rappaport describes this change in ambiguous terms. Victorian women were expected to be concerned primarily with family and home. Female shoppers could be seen as focusing on such domestic matters by buying items for their children and husbands, as well as fashionable dress for themselves, which would demonstrate the status and taste of their families. However, going shopping also meant leaving the privacy of the home, and visiting urban centres, the public sphere previously dominated by men. Shopping also focused on sensual experience, rather than more virtuous feminine occupations. In Rappaport's words, this was part of the development of the city as a 'pleasure zone', in which 'the shopper was designated as a pleasure seeker, defined by her longing for goods, sights, and public life'. Fashion therefore offered a contradictory experience. Shopping for clothes, accessories, and haberdashery allowed women to occupy a new space in the growing urban landscape of the 19th century, but it also potentially led them into a lifestyle focused on adornment and desire. Store owners worked to make their displays as seductive as possible, to persuade women to indulge themselves and spend whole days within their walls, or moving between the various shops that clustered close by in all large towns and cities.

Each store developed its own character, aiming to draw in customers who were attracted to their style, as well as to the diversity of their goods. Thus, in 1875, Liberty opened in London,

selling furniture and objects from the East, alongside 'Aesthetic' dress, historically inspired loose gowns that offered an alternative to tightly corseted mainstream fashions. Some stores opened branches in other towns or in the suburbs, including, in 1877, Britain's first purpose-built department store, the Bon Marché in Brixton, South London. Other stores launched branches in stylish seaside resorts, including Marshall and Snelgrove's Scarborough store, which was open during the holiday season. The spread of department stores brought fashionable goods to a wider range of people. Most department stores had their own dressmaking departments, as well as selling the growing array of readymade clothes becoming available in the second half of the 19th century. Stores worked hard to build up a relationship with their customers, winning their loyalty through services, quality, and price.

These developments not only changed the ways in which people could buy fabrics and clothing; it simultaneously shaped ideas about how to behave and how to dress. Store advertising suggested acceptable standards of taste, and promoted an ideal of fashionable identity. This built on the increasing dissemination of fashions and desire to be part of consumer society, which was already established at the start of the century. Although department stores embodied bourgeois ideals, they embraced a wider range of people. In 1912, Selfridges, established in London along American lines and branded with its own shade of green carpeting, stationery, and delivery vans, opened a hugely popular 'bargain basement'. The open design of department stores allowed a wide range of people to come in and look around freely. Although grander shops may have intimidated some shoppers, others would save up for a luxury item from a store whose clientele's status and style they aspired to. By the 1850s, the growth of public transport made shopping trips by bus or train simple and affordable. Underground trains in major cities would make this process even easier and encouraged the idea of a day's shopping as a pleasurable and easy source of relaxation and entertainment.

Stores worked hard to tempt shoppers with a combination of spectacular fashion shows that brought the glamour of French fashions to a wide audience and exciting new technology. In 1898, Harrods in London attracted a large crowd and much press coverage for introducing the first escalators to take people from floor to floor. While in the early years of the 20th century, American stores staged a series of Paris fashion shows, with real models parading through intricate stage sets, shimmering under specially designed electric lighting. The names of these extravaganzas evoke their atmosphere of decadence and excess. In 1908, Wanamaker's in Philadelphia held a Napoleonic themed 'Fête de Paris', complete with *tableaux vivants* of the French court. Meanwhile, in 1911, New York's Gimbels' had a 'Monte Carlo' event. Mediterranean gardens were built in the store's theatre, along with roulette tables and other props, to give an authentic feel of Riviera luxury to the thousands of people who visited.

While department stores brought fashion to the masses, opening in stylish shopping areas from Prague to Stockholm and Chicago to Newcastle, they were far from being the only source of fashion. The elite continued to frequent the court dressmakers and bespoke tailors they had gone to for generations. Tiny specialist emporia still thrived, often springing up in line with new fashions. For example, the early 20th-century craze for huge hats covered in feathers led to shops opening to sell ostrich plumes and other trimmings. Changing styles and faddish accessories also tempted male shoppers. In addition to luxurious shops selling jewellery and accessories to wealthy gentlemen were those targeting younger men, eager to spend money earned from the rash of new white-collar jobs. As with women's fashion, styles were spread by popular figures of stage and, increasingly, screen, as well as sporting heroes. A changing array of colours and patterns in ties and cravats, collar studs and cuff links would enliven men's suits each season.

Mail-order shopping was another important innovation, particularly in countries such as America, Australia, and Argentina, where the distances between cities made visiting shops in person more difficult. Department stores had their own postal sales sections, which capitalized on improving parcel mail and the introduction of telephones. Marshall Ward, based in Chicago, had perhaps the most famous mail-order service, its catalogues tempting Americans with the increasingly wide array of ready-to-wear fashions for the whole family. Improving transport methods also helped this trade, taking goods by carriers' carts and stagecoach, and then by rail.

By the first decades of the 20th century, therefore, consumerism had evolved to embrace a wide range of people of different sexes, ages, and classes. As mass-production methods improved during the 1920s, the selection of fashions and accessories available grew still further, and shops had to work harder to sell them effectively, in the face of growing competition. The already successful department stores and specialist shops were joined by 'multiples', an early form of chain store, which spread across Western countries. In America, branches of shops selling inexpensive fashions inspired by Hollywood stars' costumes gained national popularity. In the United Kingdom, Hepworth & Son, which had opened as a tailor in 1864, expanded to have menswear shops throughout the country, and is still trading, having evolved into Next, a chain store for men, women, and children. Multiple-branch shops had the advantage of central buying and administrative systems, which could keep prices affordable and manage marketing and advertising campaigns. They worked to produce a unified identity for their store designs, windows, and staff uniforms. While the dominance of chain stores by the second half of the 20th century led to accusations of homogeneity and, ironically, a lack of real choice for consumers, familiar brands reassured many customers by supplying the same type and quality of stock in each branch.

In contrast, couturiers continued to sell their designs in ways that combined centuries-old traditions with contemporary innovations. While clients were served and fitted individually, couture salons incorporated boutiques selling early incarnations of readymade lines, plus perfumes and luxury goods designed to please their elite customers. Both couturiers' salons, which were open only to private customers, and, during the show season, select store buyers and their boutiques used modern design and display techniques to demonstrate their fashion currency. In 1923, Madeleine Vionnet had her fashion house remodelled along sleek modernist lines, with classically inspired frescoes. While from the mid-1930s, Elsa Schiaparelli embarked on a series of Surrealist window displays which promoted the wit and fantasy of her designs. In each case, these artistic references related to the philosophy of their clothes and were echoed in their labelling, packaging, and advertising, producing a coherent house style for customers to identify with.

Couturiers needed to project an image of exclusivity which gave a luxurious aura to everything that bore their name. Although fashion was increasingly used as a tool to sell readymade clothing all over the world, many stores still felt that Paris was the key source of new styles. For example, American department stores and fashion houses sent buyers to the French capital each season to purchase a selection of 'models', outfits which they would be licensed to reproduce in limited numbers for their stores. These designs would have the highest fashion status in stores' collections, and would be supplemented by designs based more loosely on Paris-led trends, as well as an increasing number of styles by native designers that diverged from French diktats. Buyers thus played a crucial role, as they needed to understand the fashion profile of the stores they represented and the desires of their customers. It was crucial to keep an ever-changing array of fashions on the shop floor. In 1938, Kenneth Collins, vice-president of Macy's, addressed the Fashion Group, an organization dedicated to promoting fashion in America, stating that:

... it is one of the truisms of retailing that the difference between success and failure in the fashion business is dependent upon the ability of merchants rapidly to get into new fashions and just as rapidly to get out of them when they are on the wane.

This turnover of novel styles was fundamental to the fashion industry.

Big department stores such as Saks Fifth Avenue would have a number of lines targeted at different consumers. From 1930, it had its own luxurious creations designed by the owner's wife, Sophie Gimbel, under the Salone Moderne label, plus fashions she had chosen for the store in Paris. It then had various ready-to-wear lines, including sportswear and clothes aimed at young college girls, as well as comparable menswear styles. In combination, these collections built Saks' fashion reputation, demonstrating the store's taste and discernment in dressing the full scope of its customer base. These were sold in specially defined areas of the store to reflect their audience and purpose, and advertised in fashion magazines and newspapers at key points in the year to optimize sales.

During the Depression, many stores had to stop visits to Paris and became increasingly reliant on homegrown fashions. Despite the economic downturn, fashion magazines such as *Vogue* and *Harper's Bazaar* continued to carry advertisements for shops of all sizes. Columns such as 'Shop-Hound' in *Vogue*'s various national editions encouraged women to make shopping trips, mapping out the 'best' areas to visit and the chicest boutiques and department stores to go to. Designers and stores cultivated close relationships with the fashion media through their press representatives, who worked to obtain advertising and editorial coverage in magazines. These connections continued in subsequent decades. However, the Second World War, and the continuing deprivations it caused, interrupted the flow and availability of goods. Despite shortages and rationing in most countries involved in the conflict, the dream

of consumer goods was held out in many countries as a morale-boosting vision of the future.

As economies recovered during the 1950s, new initiatives began to develop. One of the key examples of this was the growth of designer-owner boutiques that appeared in London by the end of the decade. These demonstrated how fashion could evolve from small-scale entrepreneurs who understood their audience and the kind of clothes they wanted to wear. In 1955, for example, Mary Quant was prompted to open Bazaar on London's King's Road by her own frustration with the contemporary fashion scene:

> I had always wanted the young to have fashion of their own ... absolutely twentieth-century fashion ... but I knew nothing about the fashion business. I didn't think of myself as a designer. I just knew that I wanted to concentrate on finding the right clothes for the young to wear and the right accessories to go with them.

Quant produced fun clothes: baby-doll dresses, corduroy knickerbockers, and fruit-coloured pinafores, which helped to shape the style of the period. She and her peers spawned imitators across the globe, eager to capitalize on the trend for youth-driven, mass-produced clothes. Quant also provided a template for future designer-retailers, who would develop global reputations by dressing emerging youth cultures. Vivienne Westwood and Malcolm McClaren's shop, also on the King's Road, changed its exterior and interior design, as well as the look of the clothes it sold, in line with evolving street styles. From Teddy boy-inspired suiting as Let It Rock in the early 1970s, through hardcore Punk aesthetics in mid-1970s Seditionaries and Sex, to its final incarnation as World's End, an Alice in Wonderland-style boutique with wildly sloping floor and backwards-running clock. Westwood's design and retailing style were part of the fluidity of subculture. Styles emerged and shifted as the music, street, and art scene they were connected with moved on. This flexibility created an exciting sense of community and currency around her store,

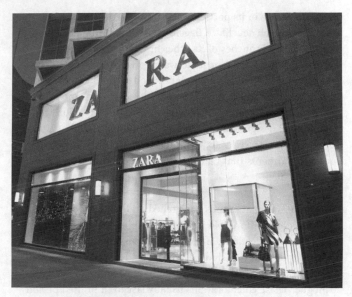

14. Zara's stores look like boutiques, and lure customers in with open frontages and carefully coordinated displays

promoted by the DIY ethos of subcultures. As with Quant in the 1960s, it demonstrated how like-minded shops could group together to generate business and consolidate the fashion reputation of an area. In the early 21st century, Alphabet City in New York saw a similar constellation of designer-makers opening up in close proximity.

Indeed, Spanish chain Zara, which is known for its mix of classic and catwalk-inspired pieces, has based its success on a strategic version of this more organic development of shopping areas. Since opening its first store in 1975, Zara has expanded internationally, overtaking its main rivals on the high street. Each store is designed to look like a boutique, with themed garments grouped together with accessories, suggesting possible outfits to consumers. The chain is owned by Inditex, which includes Massimo Dutti, Bershka,

and Zara Home in its portfolio. Its strategy is to open a large Zara shop first, which acts like a flagship, visually stating the ethos of the label, then branches of its other brands are launched close by. This encourages shoppers to walk between the shops, buying from Inditex's different labels and seeing how the clothes, accessories, and soft furnishings sold in each complement one another. Allied to this is Zara's quick response to fashion trends, with a small design team and close-knit manufacturing system, which allows new styles to be spotted and rapidly translated into new garments that reach the stores soon after they have been identified.

Other international brands have relied on their own design teams' ability to create affordable fashions, combined with celebrity and high-fashion collections. H&M has commissioned a series of lines from designers including Viktor and Rolf, Stella McCartney, and Karl Lagerfeld, as well as music stars Madonna and Kylie Minogue. These collaborations usually last for a limited period only, creating huge media coverage, and swarms of shoppers queuing to buy each collection as it is launched. The success of this approach is similar to couturiers' ready-to-wear lines and licences in the 20th century. The aura of high fashion is used to enhance the status of various mass-market stores, from America's Target chain to Britain's New Look. Perhaps the most famous collaboration of this kind has been between model Kate Moss and Topshop, the British chain store that has led the way in high-street fashion since the late 1990s. This has seen an interesting exploitation of a star's personality, style, and aura of exclusivity into a regular range for the brand's branches across the world. These clothes mimicked items from Moss's own wardrobe of vintage and designer fashions. Moss herself is also a brand, used to market the range, and even to inspire decorative devices, including the twin swallow tattoos she has on her back which have decorated everything from jeans to blouses. This takes the connection between celebrity and fashion, which had

been apparent since at least the 18th century, further than ever before.

This collaboration is demonstrative of the ever more blurred line between luxury and mass fashion since the late 20th century. In Britain, Kate Moss's collection is sold in Topshop's own high-street stores, and is therefore seen as part of a fashion-led, but undeniably mass-produced, world of throwaway fashions. However, in New York, the range was launched in exclusive fashion speciality store Barney's, giving it the air of an exclusive, luxury label that was sold alongside established high-fashion designers from across the globe.

This confusion between high and mass fashion is the result of the growing strength of ready-to-wear fashions over the past 150 years, and the strong fashion-led design ethos of high-street lines. As consumers have become more comfortable mixing vintage, designer, and cheap high-street and market finds together, the divisions between these categories has, to a certain extent, collapsed. Although prices still provide the most obvious difference, more emphasis is placed upon consumers' ability to put together an interesting and individual outfit than to adhere to fixed ideas of what is respectable. This change has not just come from the high street. Since the 1980s, luxury brands have extended their reach, moving from the elite confines of small boutiques to build huge flagship stores in major cities, as well as allowing their goods to be sold in duty-free shops and shopping centres specializing in knockdown price, old-season fashions.

In the late 20th century, luxury brands such as Gucci developed into huge conglomerates and quickly identified the Far East as the key market for their goods. Stores were opened both in mainland Japan and Korea, for example, but also in places where fashion-conscious people holidayed. Hotels in destinations including Hawaii hosted luxury boutiques where young, affluent Japanese women would shop. Blanket advertising campaigns

balanced references to the exclusive heritage of brands such as Burberry and Louis Vuitton with a cutting-edge fashion image bolstered by the appointment of young designers, in these cases Christopher Bailey and Marc Jacobs. Online fashion stores, including high-end website net-a-porter.com, have made it even easier to purchase these fashions. Many of these follow a magazine format, with exclusive offers, news and style advice, photographs and film clips from the latest collections, and suggestions about how to create an outfit, all with links to buy the items seen.

By the early 21st century, the East was the centre of both mass and luxury fashion. It was manufacturing its own lines, as well as those for much of the rest of the world, and its increasingly wealthy citizens were keen to shop for fashions too. Tom Ford, who had made his name as creative director first of Gucci and then Yves Saint Laurent, felt this marked a fundamental shift in the international balance of fashion. In Dana Thomas's book *Deluxe: How Luxury Lost its Lustre*, he is quoted as commenting that:

> this is the century of emerging markets...We are finished here in the West – our moment has come and gone. This is all about China and India and Russia. It is the beginning of the reawakening of cultures that have historically worshipped luxury and haven't had it for so long.

However, the globalization of various aspects of the fashion industry has raised ethical issues concerning, on the one hand, the potential exploitation of labour when manufacturing occurs far from the managerial centre of a company, and on the other, concerns about the homogenizing effects of consumer society, with big brands dominating so much of the world.

Chapter 5
Ethics

Formed in America in 1980, People for the Ethical Treatment of Animals (PETA) has grown to become a global pressure group for animal rights. Its campaigns encompass a number of fashion-related issues, as it forces people to confront the uses made of animals to produce, for example, fur and wool. A 2007 campaign showed British pop singer and model Sophie Ellis Bextor clad in an elegant black evening dress. Her face was perfectly made up: scarlet lips, pale skin, and smoky eyes.

This femme fatale styling was then rendered literal: in one hand, she held up the inert body of a fox, its fur flayed to reveal the red gore of its flesh, its head lolling grotesquely to one side. The tagline 'Here's the Rest of Your Fur' reinforced the message of the cruelty that underpins the fur trade. The campaign's aesthetic drew upon a nostalgic, film noir image. However, 1940s cinematic heroines were frequently shown wearing a fox fur stole draped over their shoulders as a signifier of luxury and sexuality. PETA subverted the viewers' expectations to confront them with the deathliness and horror of fur.

Other print and billboard campaigns have used a similar combination of famous faces, familiar imagery, and the shock of juxtapositions that reveal fashion's underside. The organization's

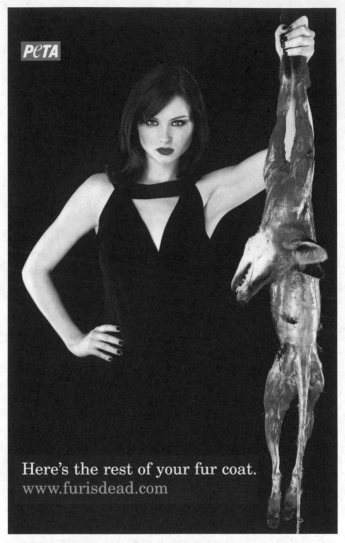

Here's the rest of your fur coat.
www.furisdead.com

15. PETA uses arresting imagery and shock tactics to reveal the fur trade's cruelty

aim is to force consumers to understand what goes on behind the sensual façade of fashion photography and marketing, and to examine the way clothes are produced and the processes involved. PETA's slogans use the punchy, direct language of advertising to create memorable taglines that will enter the popular vocabulary. Examples have included ironic double entendres that expose the contradictions at the heart of the fur trade: 'Fur is for Animals', 'Bare Skin, not Bear Skin', as well as 'Ink not Mink', which focused on tattoos as an alternative fashionable status symbol.

PETA's focus on skin itself means the connection between the living animals that provide the fur is continually restaged. Its famous 'I'd Rather Go Naked Than Wear Fur' campaign that started in the mid-1990s brought together supermodels and celebrities, who stripped and stood behind a strategically placed placard. These images were styled like fashion shoots. Despite the lack of any clothing, participants were groomed and lit to emphasize their 'natural' beauty. By using models, actors, and singers as 'themselves', a direct link could be made between their cultural status and value, and the status of PETA's campaign. The message was that if these hugely popular professionals rejected fur, then so should the consumer. Lapses, such as Naomi Campbell's late 1990s defection from PETA and subsequent avocation of fur wearing and, indeed, hunting, have done little to diminish the power of its message. In the early 21st century, a new selection of names, including actress Eva Mendes, signed up to the cause. Images included 'Hands off the Buns' featuring naked celebrities carrying white rabbits.

PETA has raised animal rights' profile within the fashion industry. Its members have invaded catwalks, thrown paint, and famously a frozen animal corpse, at those the organization perceived to be responsible for fur's continued place within fashion, and pushed for new regulations on the treatment of sheep in the wool trade. Its activists' work has not just underlined the needless cruelty involved in the fur trade; it has

also shown how fur is often misunderstood as a 'natural' product to wear, despite the fact that most fur is farmed and, once obtained from the animal, goes through various chemical treatments to remove the flesh and prepare it to be used as fabric.

Although PETA's aims are admirable, their approach raises further ethical questions. The group's appropriation of the visual language of fashion and, indeed, wider youth culture has led to accusations that it continued to sexualize and exploit women in the name of animal rights. This is a familiar charge: British-based Respect's 1980s campaign 'One Fur Hat, Two Spoilt Bitches' depicted a model with a dead animal stole and was also seen as positioning women as dumb, sexualized objects. This tension problematized the campaign's message. It can be read as another means to grab the viewer's attention, confront her with the thoughtlessness of wearing fur, and shock her into taking notice. However, to do this, it deployed the highly sexualized visual codes that dominate much contemporary advertising. This controversy highlights the contradictory impulses present within such campaigns. While great focus is placed upon one ethical problem, another equally significant moral issue is accepted, and arguably embraced, as the status quo.

The fashion industry's status is ambiguous. It is a hugely profitable international business and source of pleasure to many, yet it also incorporates a range of moral tensions. From the way women are depicted to the way garment workers are treated, fashion has the ability to represent both the best and the worst of its contemporary culture. Thus, while fashion can be deployed to shape and express alternative as well as mainstream identities, it can equally be repressive and cruel. Fashion's love of juxtapositions and exaggeration can frustrate and confuse, or even reinforce, negative practices and stereotypes. Its focus on appearance has led to its continual condemnation as superficial and narcissistic.

Los Angeles-based T-shirt manufacturer American Apparel is another case in point. Its mission statement has, from the company's inception in 1997, sought to move away from outsourced manufacturing to create a 'sweatshop-free' production line. Unlike other brands that focus on basic wardrobe staples, it has refused to have its garments made up in developing countries, where it can be hard to maintain control of workers' rights and factory conditions. American Apparel instead uses local people, and thus contributes to its community. Its shops include in-store exhibitions of locally and nationally known photographers, and its cool, urban basics have become hugely popular internationally. Its advertising campaigns reinforce its ethical credentials and focus on its workers, frequently using its own shop assistants and administrative staff as models.

However, once again the mode of representation used has caused widespread comment. Dov Charney, the owner of American Apparel, favours a photographic style that is akin to snapshots – candid images of young women and men, often semi-clad, their bodies twisted towards the camera. As Jaime Wolf wrote in a *New York Times* article:

> the ads are also highly suggestive, and not just because they are showcasing underwear or clingy knits. They depict young men and women in bed or in the shower; if they are casually lounging on a sofa or sitting on the floor, then their legs happen to be spread; frequently they are wearing a single item of clothing but are otherwise undressed; a couple of the young women appear to be in a heightened state of pleasure. These pictures have a flashbulb-lighted, lo-fi sultriness to them; they look less like ads than photos you'd see posted on someone's Myspace page.

This aesthetic is not new; it draws upon Nan Goldin's and Larry Clark's graphic images of youth culture from the 1970s. Nor is it unusual to see it used within fashion imagery: Calvin Klein has, for decades, used a similar combination of arresting shots of young

models to promote simple designs. It permeates style magazines and online social sites, as well as American Apparel's own website, which presents the images as collections to flick through. They therefore used a familiar set of visual codes in their unstaged-looking set-ups and their casual sexuality.

American Apparel's imagery used a fun, sexy aesthetic that might be expected of a youth-orientated company, but which jarred with traditional ideas of the way a 'worthy' company concerned with ethical issues should be presented. As with the anti-fur campaigns, when a product or cause is positioned as ethical, the use of potentially dubious, sexualized imagery is particularly open to be judged. If one aspect of contemporary morality is being addressed, this sharpens awareness of other possible issues contained within every aspect of an organization or brand's output. While the imagery American Apparel uses chimed with its target youth audience's tastes, it simultaneously exploited an amateur porn aesthetic that had come to pervade early 21st-century culture. Since fashion's own moral status is so fraught, and its role in constructing contemporary culture can be so problematic, it is perhaps unsurprising that ethical messages and practices can be perceived to be undermined by communication methods and representational styles.

Identities and transgressions

While ethical issues that relate to how fashion is produced have gained in significance since the later 19th century, it was the ways in which fashion could be used to change someone's appearance that drove earlier commentaries. Moral concerns centred on the ways that fashion can play tricks, enhancing the wearers' beauty or status, and confusing social codes and acceptable ways to dress and behave. Fashion's close connection to the body and garments' ability to disguise flaws, while also adding sensual fabrics' allure to the figure, added to moralists' fears about both the wearers' vanity,

and the effect fashionable clothing had on onlookers. Historically, more was written by those who felt fashion implied narcissistic tendencies, pride, and foolishness than by those wishing to praise it. In the 14th century, for example, text and imagery depicted over-emphasis on appearance as sinful, since, for men and women, it signalled a mind focused on surfaces and materialism rather than religious contemplation. Wearers' uses of fashion to create new identities or to subvert conventional expectations about how they should look meant it could challenge social and cultural divisions, and confuse onlookers. Such anxieties have remained central, where transgressions from the norm have potentially brought moral outrage upon fashion and its adherents.

Although respectable women and men were expected to demonstrate awareness of current fashions in their dress, too much attention to detail was open to question. Fashion was also judged as inappropriate to older people and to the lower classes. This did not, however, prevent fashion's spread. In the 17th century, Ben Jonson's play *Epicoene, or The Silent Woman* included comments that reveal some of the key issues that made fashion dubious. In the play, plain women were deemed more virtuous, while beauty was claimed to entrap men. It also chastized older women who sought to follow fashions in dress and beauty. The character Otter asserts that his wife has:

> A most vile face! And yet she spends me forty pounds a year in mercury and hog's bones. All her teeth were made i'the Blackfriars, both her eyebrows i'the Strand, and her hair in Silver Street. Every part of the town owns a piece of her.

The idea that beauty could be bought, in this case including mercury to turn the face fashionably pale, underlined fashion's inherent duplicity. Mrs Otter's shopping trips meant her appearance belonged to fashionable retailers rather than to nature. She was not just tricking her husband, therefore, but foolishly spending money to recapture her youth.

This theme was developed in sermons, pamphlets, treatises, and imagery in subsequent periods. In the late 18th and early 19th centuries, caricaturists, most notably Cruickshank and Rowlandson, showed elderly women transformed by wigs and beauty preparations, their bodies remoulded by padding and hoops that defined the figure and brought it in line with contemporary ideals. In the 1770s, it was towering wigs topped by foot-long feathers that were most mocked; by the following decade, it was the padding added to the back of dresses; and by the turn of the century, thin women were ridiculed for looking even skinnier in newly fashionable column dresses, while plump women were taunted for looking fatter in the same fashions.

Such criticisms reflected attitudes to women, their bodies, and their status in society. While women were certainly viewed as less important than men, moralists policed their clothing, gestures, etiquette, and deportment. Class also played a significant role, with differing standards and expectations for elite and non-elite women. Importantly, all women were expected to uphold a respectable appearance, to distinguish themselves from prostitutes, and avoid bringing shame upon their families. Women therefore needed to think carefully about how they used fashion; too much interest was problematic, but too little interest could also render women dubious. Fashion's role in shaping gender meant that it was a significant element in people's projection of their individual and group identity. Men were far less criticized for their choices, but they still had to maintain their appearance in relation to their class and status. However, younger men who were too interested in fashion did come in for strong moral condemnation. In the early 18th century, *The Spectator* magazine described foppish students as 'vain Things' who, just like women, 'regard one another for their vestments'. This was perhaps the last period when fashionable menswear was already flamboyant in colour, decoration, and style, and therefore greater effort was needed in order to be transgressive. As *The Spectator* indicated, to do so was to challenge expectations, and risk being regarded as feminine.

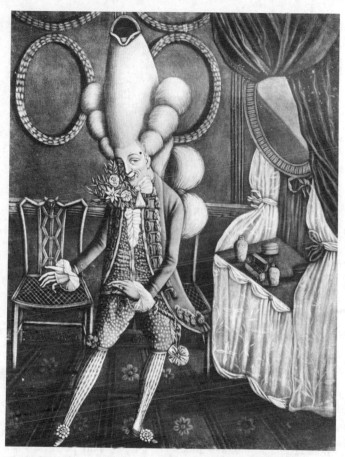

16. Eighteenth-century Macaronis were mocked for their exaggerated style and self-conscious deportment

Doubts were cast about the sexuality and gender of many such men. In the 1760s and 1770s, Macaronis, like Fops, who were their most direct predecessors, drew ridicule from caricaturists and commentators. Named after Italian pasta, these young men flaunted their associations with the Continent in their brightly

coloured clothes. Their clothing exaggerated contemporary fashions and featured oversized wigs, which were sometimes powdered red or blue instead of the more usual white. They wore coats that were cut extra-tight and curved towards their backs, and were often depicted posing in an affected manner. Macaronis thus offended masculine ideals on a number of counts; they were deemed effeminate, unpatriotic, and vain. Various loosely formed groups of overly fashionable young men superseded them, each of whom used dress to flaunt difference and transgress social ideals. These included the Incroyables of the French Revolution and, in the 19th century, Swells and Mashers in England and Dudes in America. In each case, exaggeration, 'foreign' fashions, and close attention to grooming and accessories distinguished their style and brought claims that they were threatening masculine ideals, and therefore the status quo.

From 1841, *Punch* magazine took pleasure in ridiculing fashions, as well as showing women in crinolines, corsets, and bustles contorted into elaborate shapes in the name of fashion. Alongside these satirical comments were more serious complaints from doctors that women risked their health when they wore whale-boning, but these did little to deter the popularity of such garments. Gender continued to be a major issue. Women needed to wear such underwear in order to be perceived as feminine, yet they were accused of irrationality for wearing such restrictive garments. This double bind extended to clothing that could be seen as too masculine, even if it was more practical than high fashion. In the 1880s, when women began to enter white-collar jobs, the so-called tailormades that they wore, based on a male suit but worn with a skirt, were seen as turning women into men. Indeed, as in all these examples, dress was seen as a signifier of the wearer's gender, sexuality, class, and social standing, and any ambiguities could lead to misunderstandings and condemnation.

This is apparent in the lingering idea that women should not wear trousers, which were felt to disrupt gender roles and imply that women aimed to take on men's powerful status. These concerns extended well into the 20th century. In 1942, the number of women wearing trousers whom she saw in Paris appalled actress Arletty. Despite the hardships of the war, she felt there was no excuse for such behaviour, and that:

> It is unforgivable for women who have the means to buy themselves boots and coats to wear trousers. They impress nobody and their lack of dignity simply proves their bad taste.

This not only revealed the horror with which loss of femininity could be perceived, but stressed the social element of such moral judgements. Working-class women in certain occupations, including mining and fishing, had worn trousers or breeches since the 19th century. However, they were effectively invisible – literally, unseen by most people outside their immediate environment, and metaphorically, since the middle classes and the elite did not value them.

Class has been a persistent theme within moral concerns about the ways in which fashion can disguise someone's true status, or indeed flaunt it as defiance against authority. In the 20th century, establishment mistrust of dress that defied middle-class ideals of respectability and decorum was compounded by the rise in the number of deliberately provocative subcultural groups. In early 1940s France, 'Zazous', both male and female, caused consternation with their elaborately detailed suits, sunglasses, and American-inspired hairstyles and cosmetics. Public and media outrage at their fashions brought together a number of familiar issues. Foreign styles were seen as unpatriotic, particularly during wartime restrictions, even if the Americans were Allies. Exaggerated garments and make-up broke class-based notions of good taste, and paraded Hollywood's overblown style of self-presentation. Although their styles remained confined to a

small number of youths, Zazous' emulation of film-star fashions and love of jazz music was a visual and aural confrontation with French culture, at a time when it was already under threat from Nazi occupation of the country.

In subsequent decades, youth culture presented a continued disruption to social codes of behaviour and display. In Britain, class played a significant part in shaping subculture's nature. In the 1960s, Mods aped middle-class respectability in neat, sharp suits, while Skinheads toughened up this style to assert a strong working-class identity, based on workwear. In each case, youth style was driven by a combination of its members' search for excitement and devotion to particular music styles. In the early 21st century, a more diffuse group within working, and unemployed, youth emerged. 'Chavs' were condemned as tasteless, for their unselfconscious flaunting of obvious branding and disregard for middle-class ideals of style. Media coverage exposed embedded class prejudice, as the term quickly became associated with criminality amongst teenagers on council estates. Chavs' aggressive sportswear styles were connected to negative stereotypes of the working class, as an easily grasped visible incarnation of inner-city lawlessness.

Media outrage at each new incarnation of youth style demonstrated the impact that such breaches of the status quo had. In Japan, Tokyo's Harajuku area has, since the 1980s, been a focus for street fashions, as young people evolved new ways to wear and combine garments. Teenage girls upset traditional ideals of femininity to create spectacular new styles which freely combined elements from a range of sources, including high fashion, past subcultures, cartoons, and computer games. Indeed, their composite styles mirrored the fantasy self-styling of computer avatars, which are hugely popular in the Far East. Harajuku's street fashions defy parental expectations that girls should present a demure and restrained image. Pop singer Gwen Stefani's creation of a team of four 'Harajuku Girls' dancers, who appear in her

videos and live performances, added another layer of controversy to these styles. Korean-American comedian Margaret Cho has criticized Stefani's appropriation of this Asian fashion style and her use of these 'Harajuku Girls' as offensive, and stated that 'a Japanese school uniform is kind of like a blackface'. This suggested that the dancers represented a stereotype of ethnic identity, used to enliven a white performer's show. Stefani's fashion is itself influenced by Japanese street style, but her dancers take this further. They literally embody concerns not just about foreign inspirations in dress, but more seriously, who has the power to make such appropriations, as well as ethical concerns about ethnic stereotyping.

Another, very different incarnation of this is the confused and often excessive response to young Muslim women who choose to wear the hijab as a symbol of religious and ethnic identity. Post 9/11 fears of Islam, combined with public and media perceptions of such displays of difference as transgressive, have led to girls being banned from wearing the hijab in some French schools. This has caused outcry, and hardened some Muslim women's belief in the importance of the hijab as a symbol of not just their religion, but also to question Western ideals of femininity and exposure of the body in contemporary fashion.

This issue sharpens the way specific examples of moral outcry concerning the way ethnic minority groups are presented and treated in relation to dress and appearance. The under-representation of non-white women within the modelling world is a major problem within the industry. Despite media protests and one-off editions, such as Italian *Vogue*'s July 2008 edition, which used black models throughout its editorial pages, white women dominate on the catwalk, as well as in fashion photography and advertising. As leading model Jourdan Dunn, who is herself black British, remarked, 'London's not a white city, so why should the catwalks be so white?' Fashion's persistent disregard for diversity is symptomatic of inherent racism within the wider culture.

Representation, in terms of actual models and their images within magazines, requires a shift in attitudes within the fashion industry and a recognition that it is unacceptable to continue to focus on white models.

Regulation and reform

Alongside protests against the ways men, and particularly women, are represented in fashion imagery, there have been various attempts to control or manage the ways in which fashion is produced and consumed. During the Renaissance, sumptuary laws continued to be imposed to try to maintain class distinctions, by limiting certain fabrics or types of decoration to particular groups, or to impose ideals of modesty on the population. For example, in Italy, legislation was passed that sought to regulate attire worn for rituals such as weddings, as well as to limit the amount of décolletage women of different classes were permitted to display. Such laws were regularly instigated across Europe, although they had limited success, since they were difficult to police. As Catherine Kovesi Killerby has written in relation to Italian laws that expressed social concern about excessive display in dress, 'by their very nature, [they] are self-defeating: to curb luxury by the outlawing of one form that luxury happens to be taking itself generates new forms as the way to avoid persecution'. Since fashion continually mutates, albeit at a slower rate during this early period, it is hard for the legislature to keep up with these changes, and as Killerby notes, wearers are equally inventive, changing styles to dodge laws and create new incarnations of a style.

Sumptuary laws declined during the 17th century, although they were resurrected with greater success during the Second World War. While earlier periods had seen bans imposed on importation of foreign goods for economic and nationalistic reasons, the length and extent of this war meant any such laws were compounded by severe restrictions on international trade due to widespread sea

and air warfare. Shortages led to rationing in many of the countries involved. In 1941, Britain regulated production and consumption of clothing, by issuing coupons that could be exchanged for garments throughout the year. The number of coupons issued to each person changed over the course of the war and post-war period, but imposed a serious limit on access to clothes. Regulations in Britain, America, and France also stipulated how much fabric could be used in clothing production, and stripped back the amount of decoration that could be applied. This stark shift in access to fashion was tempered by the British Utility scheme that employed well-known fashion designers, including Hardy Amies, to design outfits that followed the legal limitations while remaining stylish. The lack of new clothes meant it was hard to circumvent wartime restrictions, though, and public and media attitudes hardened towards excess, which was seen as unpatriotic and against the war effort.

After the war, Soviet bloc countries were able to continue this limit on fashions and attempted, with varying degrees of success, to condemn fashion as anti-socialist. In East Germany, Judd Stitzel writes that:

> officials sought to channel and control female desire by connecting women's rights as consumers with their roles as producers and by promoting rational 'socialist consumer habits' as an important component of citizenship.

Work-inspired garments including aprons and overalls had limited appeal, however, and, as in other socialist countries, including Czechoslovakia, an uneasy coalition of state-sanctioned fashions and fashion imagery was developed alongside more functional styles. These attempts to reform fashion and strive for a more ethical form of dress harked to 19th-century dress reformers such as Dr Gustav Jaeger who had encouraged men and women to reject fashion's excess and adopt natural-fibre clothes, and feminists in

Europe, Scandinavia, and America who called for greater equality and rationality in clothing.

Late 20th- and early 21st-century versions of these impulses to regulate and create clothing that does not harm animals, people, or the environment have begun to make inroads into mainstream as well as niche fashion. Spurred on by the Hippies and connected movements in the 1960s and 1970s towards more natural fashions and concern for ethical issues, at the turn of the 21st century designers as well as bigger brands tried to reconcile developments in consumerism with the need for more thoughtful design and production practices. Since the early 20th century, moves were made to regulate wages and conditions for workers. This was prompted by disasters such as the Triangle Shirtwaist Factory fire in New York in 1911, when 146 immigrant workers were killed. The factory contained an unknown number of subcontracted, poorly paid workers in an overcrowded, cramped environment, which meant that many could not escape the blaze that broke out on the top floors. Although such incidents brought widespread protests against sweatshops and calls for a minimum wage, these practices still have not been eliminated. As rents rose in major cities, mass production moved further out, and eventually migrated to poorer countries in South America and the Far East, where labour and property was cheap. So-called 'Fast Fashion', where brands strive to provide the latest fashions as soon as they have been seen on the catwalk, has led to strong competition to introduce new styles throughout the year, at the cheapest prices possible.

Popular high-street names have been accused of using suppliers that rely on child labour. In October 2008, a report by the BBC and *The Observer* alleged that three of low-cost brand Primark's suppliers used young Sri Lankan children from refugee camps in India to sew decoration onto T-shirts, in appalling conditions. Primark sacked these suppliers as soon as it was made aware of the situation, but the report suggested that there was a problem at the heart of the contemporary fashion industry. Cheap clothing's easy

availability democratized access to fashion, but also encouraged consumers to view garments as short term and throwaway, and, combined with fierce competition to produce the cheapest lines, makes exploitation a potential consequence. Mass-market fashion chains have stated that their huge sales volume meant that their clothes could be inexpensive. However, there can be an ethical cost to this approach, as well as a human cost, as supply chains become increasingly diffuse and difficult to track. Journalist Dan McDougall has stated that:

> in the UK the term 'rush to the bottom' was coined to describe the practice of international retailers employing developing world contractors, who cut corners to keep margins down and profits up for western paymasters.

Primark is not the only chain store to face criticism; others, including American-based Gap, have also had problems with their suppliers. Labels such as People Tree in Britain have therefore sought to distance themselves from this approach, and have established close ties with their suppliers, to seek to create sustainable production patterns that can benefit local communities in the countries where their clothes are made. Bigger brands including American Apparel have taken action to prevent sweatshops by using local employees. Both brands have also worked to use fabrics with a low impact on the environment. The poisonous bleaching and dying processes used in denim and cotton production have prompted organic and unbleached ranges to emerge at all levels of the market. What distinguished the clothes produced from earlier ranges in previous decades was manufacturers' recognition that consumers expect fashionable design values even from ethical goods. Smaller labels such as Ruby London, which included a selection of fashionably skinny-cut organic cotton jeans in its range, and Ekovarnhuset in Sweden, which sells its own line as well as other eco-fashion labels, have created clothes that are fashionable as well as environmentally

conscious. Even big brands including H&M, New Look, and Marks and Spencer introduced organic cotton lines. High fashion incorporated a growing number of ethical labels too. Stella McCartney refused to use fur or leather, while Danish designers Noir combined cutting-edge fashion style with a strong ethical company policy that included support for the development of ecologically sound textiles.

Other designers promoted the idea of buying less, but investing in more expensive pieces that would last longer. This 'Slow Fashion' encompassed ranges such as Martin Margiela's 'Artisanal' line of handmade garments. *The New York Times*' Armand Limnander broke down the relative cost of these luxury designs to calculate that, for example, a Raf Simons at Jil Sander made-to-order man's suit at $6,000, which took 22 hours to make, was therefore priced at $272.73 per hour. While this did not estimate the cost per wear, it advocated a shift in attitude that rejected quick turnover of styles and seasonal purchases of the latest trend. Not everyone, though, can afford the initial investments needed. However, Slow Fashion identifies one of the core issues within making fashion ethical: that consumption itself is the problem. Fashion's environmental impact spans a wide range of issues from production methods and the practices involved in growing natural fibres such as cotton, to mass consumerism and the public's desire for new fashions.

Japanese chain Muji's recycled yarn knit range suggested one solution; Paris-based Malian designer XULY Bët's designs made from reused old clothes another. These clothes rely upon second-hand textiles and garments, and can be seen in conjunction with the shift towards vintage and flea-market fashion shopping since the late 20th century. These fashions have less impact on the environment and reduce the production process, but they are unlikely completely to replace the existing fashion industry, especially given its huge international reach and the amount of finance tied up in its production and promotion.

There is also a danger that ethical shopping itself becomes a trend. As a global economic downturn set in during the first decade of the 21st century, reports questioned the idea of 'recession chic' and 'feelgood consumerism', based on people's sense of virtue when they bought organic and ethically produced clothes, even if their purchase was actually unnecessary. The question remained whether consumers were willing to own less and to rely less on shopping as a source of leisure and pleasure, and whether ethical brands can assert a new approach to assessing what to buy and remain viable businesses.

Counterfeit markets across the globe which sell copies of the latest 'It' bags demonstrate the continued allure of status symbols, and fashion's ability to seduce consumers eager for an object associated with luxury and elite style. As fashion's reach has spread across the social spectrum and incorporated internationally known brands, it has become increasingly difficult to police its production or

17. Markets in the Far East sell counterfeit versions of the latest luxury brand 'It' bags at a fraction of their retail price

regulate its consumption. This could only be achieved by a major realignment of social and cultural values, and a change in approach from a global industry that had grown up over centuries to lure customers and satiate their desire for the tactile and visual allure of clothing.

Chapter 6
Globalization

Manish Arora's autumn/winter 2008–9 collection was shown against the backdrop of artist Subodh Gupta's installation of neatly arrayed stainless-steel cookware. This metallic scenography provided an ironic comment on clichés of Indian culture. Gupta's glittering display was also a foretaste of the hard silver and gold tones that dominated Arora's show. His models were dressed as futuristic warrior women. He used a mix of historical references to create gleaming breastplates, stiff mini skirts, and articulated leg pieces. Roman gladiators, medieval knights, and samurai were all evoked, with spiny silver facemasks to reinforce the image of power. These international inspirations were taken further in Arora's trademark use of vividly coloured three-dimensional embroideries, beadwork, and appliqué. These added to the combination of old and new, in their display of traditional Indian craftsmanship that used glittering Swarovski crystals to enhance the effect.

Arora's collaborators were equally diverse. Japanese artist Keiichi Tanaami contributed his psychedelic imagery of huge-eyed children and fantastical beasts as templates for the decoration applied to dresses and coats. Walt Disney's Goofy, Mickey and Minnie Mouse were re-imagined in armour and helmets on a series of garments. The result was a collection that underlined

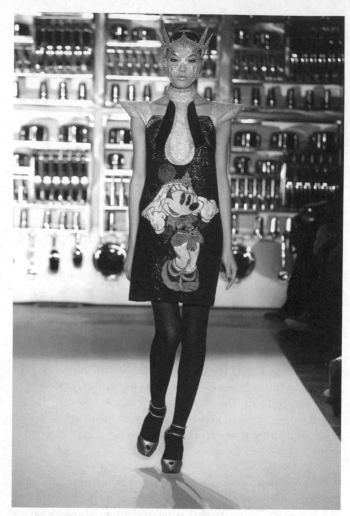

18. Manish Arora's 2008–9 collection included warrior-woman imagery and embroideries of Walt Disney characters

Arora's ability to produce a coherent look from seemingly unconnected influences and ideas, as well as to reinforce his status as a global designer, able to erase stark definitions of East and West in his elaborate designs. Since he set up his label in 1997, Arora has produced imaginative work that incorporates traditional embroideries and other decorative techniques with Pop Art style colourings and myriad reference points. This embellishment spoke of luxury and excess, and catalogued in minute detail his progress within the fashion industry. During his time showing at London Fashion Week, city panoramas of the Houses of Parliament and the Trooping of the Colour crowded onto full skirts – then, while showing in Paris, the Eiffel Tower appeared. From the start, he aimed to establish a global luxury brand which catered to the tastes of both Indian and international audiences. Indeed, his style rendered these distinctions ever more anachronistic. In most cases, there was no difference between them, and, as Lisa Armstrong noted, Arora 'doesn't seem to be pandering to foreign markets – or attempting to dampen his exuberance'.

The early 21st century saw a steadily growing schedule of fashion weeks across the globe, instant dissemination of trends via the Internet, and financial and industrial growth in countries such as India and China. Arora's own success was a product of India's developing confidence as a fashion centre. It had a long-established reputation for its textiles and craft skills, but it was not until the late 1980s that it began to construct the infrastructure necessary to build a fashion industry. Couture designers began to emerge, and colleges, including the National Institute of Fashion Technology in New Delhi, where Arora studied, educated a new breed of designer. In 1998, the Fashion Design Council of India was set up to promote Indian designers and seek sponsorship. This made it possible for ready-to-wear labels to evolve, and thus created the basis for a broader-based fashion industry with further reach beyond India. Arora's entrepreneurial ability enabled him to gain worldwide publicity, and lucrative design connections. For example, he has produced a range of shoes for Reebok, a

limited-edition watches line for Swatch, and a cosmetics collection for MAC that displayed his signature neon-bright colours and love of shimmering surfaces. Business deals such as these provided the platform for Arora to expand his brand.

However, his success should not just be judged by his recognition within the West. Rather, as part of a developing breed of non-Western designers able to command international sales and attention, Arora represented a gradual shift away from the West as the fashion world's core. This process is by no means complete; it is notable that Arora showed in London and Paris to raise his profile with international press and buyers, while still showing in India. The rise of the middle and upper classes in India, though, meant that he and his peers had a considerable potential domestic market, as is the case in other countries that have invested in fashion, including China.

Western fashion cities also benefited from the cachet of including international designers in their programme. London Fashion Week had struggled to maintain its profile and to encourage foreign media and the all-important store buyers to attend its shows. In February 2005, journalists Caroline Asome and Alan Hamilton described how names such as Arora, along with Japan-based Danish-Yugoslavian-Chinese duo Aganovitch and Yung, added interest and diversity to its schedule. These international designers showed alongside London-based Nigerian Duro Olowu, Serbian Roksanda Ilincic, and Andrew Gn from Singapore. Such global names within one city underlined fashion's international scope, and suggested that while national and local styles may in the past have been useful to market designers as a group, these distinctions were less meaningful as a wider range of fashion cities emerged and designers were, subject to financial backing, able to show their collections in any number of sites. Fashion's geography had begun to shift, but as Sumati Nagrath noted, 'since the Indian fashion industry [for example] is a relatively new entrant on the global fashion scene, it has meant that in order to participate

in it, the "local" industry has perforce had to operate within a pre-existing system'. However, as other regions evolve, and movement of goods and labour alter patterns of production, the fashion infrastructure that crystallized during the late 19th century may itself begin to alter its focus.

Paris consolidated its position at the centre of Western fashion at this time, but even by the early 20th century, the French fashion industry was concerned about superior business practice in the United States. Once American ready-to-wear developed its own signature during the Second World War, it became possible for ready-to-wear, rather than just couture, to generate fashions. As post-war reconstruction drew upon the American model, and more relaxed styles including jeans and sportswear were marketed internationally, a fundamental shift occurred in fashion even though Paris still wielded considerable influence. Perhaps in the early 21st century a similar process was in train, and this was not necessarily a completely new development. In fact, it represented, at least in the case of India and China, the resurrection of luxury and visual display in dress in countries that had a long history of skills in these areas that had been interrupted by colonialism, politics, and war.

Trade and dissemination

Trade routes had transported textiles across the world since the 1st century BC, linking the Far and Middle East to European cities that dealt in rich textiles. Italy was a gateway between East and West, and had established itself at the heart of the luxury trade in textiles. Northern Europe developed centres for wool production, and Italy was famous for its multi-coloured designs in rich silks, velvets, and brocades. Cities including Venice and Florence produced the bulk of Europe's fine textiles, and its fabrics sometimes bore the imprint of the Mediterranean trade that helped to create them, with Islamic, Hebrew, and

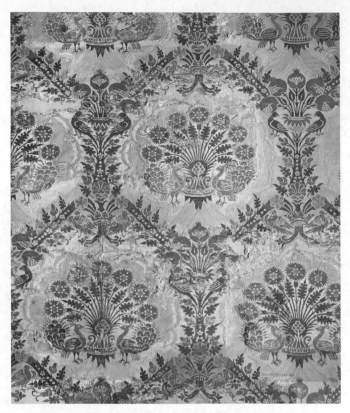

19. Renaissance textiles often combined motifs from Europe, and the Middle and Far East

Eastern texts and designs combined with Western motifs. These cross-cultural reference points were a natural result of trade, which developed during the Renaissance, as nations sought to control particular zones or find new land. During the 15th and 16th centuries, trade grew between a wider range of European countries, and links were made between Portugal, Syria, Turkey, and India and South East Asia, and between Spain and the Americas.

In the early 17th century, first England and then Holland established East India Companies (EIC) that formalized and organized their trade with India and the Far East. Initially, as John Styles has noted, the English EIC was most interested in exporting wool to Asia, and only brought back tiny amounts of very luxurious Eastern textiles, as their designs had limited appeal in England. However, in the second half of the 17th century, the EIC sent patterns, and later samples, to its Indian agents, which encouraged production of patterns based upon an English idea of the 'exotic'. These became very popular, and meant that Western fashion, which drew upon such materials for its impact, incorporated larger amounts of Eastern products. Europe had developed sophisticated maritime knowledge and transport methods to enable this trade, and exploited the innovation, flexibility, and skill of Asian craftspeople. They produced a diverse range of materials, and responded quickly to customer tastes. This produced fertile ground for cross-cultural interchanges and produced designs that merged references from various countries and ethnicities. However, Western taste dominated, and shaped the ways that Asian motifs were used. Consumers were encouraged to appreciate styles from far-flung countries, as reconfigured by EIC representatives who were aware of their tastes and aspirations. The global textiles trade was driven by luxury fabrics' appeal to the senses and Western interest in an emerging idea of exoticism, and was underscored by its considerable money-making potential. This was based upon the elite's desire for extravagant display, something that was common to all countries.

Dress styles tended to remain distinct, despite specific types of garments making the transition from East to West. This included kaftan-like dressing and wrapping gowns worn by European men and women for informal occasions at home, and a parallel fashion for turbans that was well established by the end of the 17th century. Portraits of the period show Western men relaxing in shot-silk wrapping gowns, with turbans covering their shorn heads, as a welcome escape from the powdered wigs they wore in public.

Indeed, Peter Stallybrass and Ann Rosalind Jones have argued that 17th-century identities were less tied to ideas of nation or continent. They analysed Van Dyck's portrait of Robert Shirley, English ambassador to Persia from 1622, to show how membership of the elite was far more central to identity at this time. Shirley is shown in Persian dress appropriate to his social rank and professional status. The lush embroideries of his garments, with polychrome silks on golden ground, demonstrate how much more developed such skills were in the East, and the sumptuousness of Persian attire. Stallybrass and Jones suggest that Shirley would not have perceived himself as European, since this region had no coherent identity at the time. Nor would he have assumed superiority due to his Westerness. He would, they argue, have easily adopted Persian dress as a marker of his new position and as a signal of his deferential relationship to the Shah. Fashionable identities were equally connected to ideas of class and status, but they also connected to regional or court ideals of taste and individual ability to adopt and interpret current trends. However, as Shirley's portrait shows, this identity could incorporate elements of other ethnic expectations for particular social or professional occasions, and, importantly, when living or travelling abroad. The vogue for Turkish-inspired loosely wrapped dresses amongst European women during the following century is further evidence of this, as are the adaptations of real Turkish garments by female travellers such as Lady Mary Wortley-Montague.

Indeed, it would seem that during the 17th century ideals of luxury and display were common to Eastern and Western noble and court circles. Carlo Marco Belfanti has shown that fashions developed in India, China, and Japan during the 17th and 18th centuries, with particular tastes and cycles of styles becoming popular. In Mughal India, for example, tailoring was experimented with, a love of excess permeated design, and fashions in styles of turbans and head wraps emerged. Fashions in cut and design of clothing were also present amongst clerical workers in bigger cities. However,

Belfanti argues that while fashion itself evolved in both East and West simultaneously, it did not become a social institution in the East, and proscribed forms of dress became the norm by the 19th century.

Cross-cultural references spread beyond the elite, though, and represented global influences based upon trade, but reliant upon designs that engaged audiences in the East and West. The West developed its own interpretations of designs from the East. In the mid-18th century, *chinoiserie* decorative styles had swept Europe. Aileen Ribeiro describes these re-imaginings of the East, which prompted textiles covered in pagodas and stylized florals, amongst other reinvented Chinese motifs. This trend can be seen as part of an aristocratic love of dressing up, in this case in a fantastical version of other ethnic and cultural styles. China became a popular theme for masquerades, and the Swedish royal family even dressed the future King Gustav III in Chinese robes while at its summer palace in Drottningholm.

Chinoiserie was a fashion that resulted from fanciful Western interpretations of Eastern design. However, the huge popularity of Indian chintzes during the 18th century showed the impact that Indian fabric manufacture and print design could have upon a market that extended well beyond Europe to include colonies such as those in South America. The cheapness of many Indian cottons meant they were within the reach of a far wider population than ever before. This also meant that international tastes in textile design and type, as well as access to fashion, and easy-to-wash clothes were within the reach of all but the poorest. In fact, in the 1780s the so-called 'calico craze' caused consternation amongst governments, who feared their indigenous textile trades would be made redundant. Sumptuary legislation was passed in various countries, including Switzerland and Spain, while in Mexico Marta A. Vicente writes that women reportedly sold their bodies to buy these foreign fashions. Ultimately, though, what Western countries discovered from this quickly spreading fashion was that rather

than fighting its popularity, they should use it to build up their own textile industries, and apply what they could learn from Indian textile producers to profit from the craze, as was the case in Barcelona, for example.

This was part of what would become a significant global shift from the innovative and adaptable Indian textile trade towards the increasingly industrially led West, which would gain pace during the 19th century. As England in particular developed a succession of inventions designed to speed up textile manufacture, it overtook Indian textile production, and this led to the almost complete abandonment of trade in hand-woven Indian textiles by the 1820s. Fashion had shifted its balance of power in terms of textile production as Western countries began to rely far more upon their own manufacture and export of fabric, rather than imported cottons. The Western fashion system quickly emerged in the form that would dominate for the coming century and beyond. Mechanization enabled European, and later American, textile mills to respond rapidly to tastes and fashions. In the 1850s, European inventions of synthetic dyes, notably William Perkin's discovery of vivid mauve aniline colours, all but wiped out the natural dyes industry in other parts of the world. Sandra Niessen has noted that this led to these new, vibrant hues spreading across the globe, which altered the look of traditional as well as fashionable dress everywhere from France to Guatemala.

The build-up of Western-owned colonies over the course of the 19th century saw the exploitation of textile trades in the hands of European powers. Despite racist attitudes apparent within Victorian culture, both elite and middle-class consumers continued to admire non-European products. This included Indian textiles and Japanese dress. Arthur Lasenby Liberty's department store on Regent Street in London was established in 1875. It sold furniture and decorative items from the East, as well as clothing and textiles inspired by the owner's admiration for looser, more softly coloured Asian designs and the draped gowns of

medieval Europe. However, Tomoko Sato and Toshio Watanabe have shown that Liberty's attitudes to the East were conflicted, and expressed the vexed relationship between Western exoticized ideas and the reality of Asia. In 1889, he went to Japan for three months, and, like other contemporary commentators, was pleased to see that silks had become thinner and easier to handle under Western influence, but did not approve of changes in colour and design that had also occurred. Once Japan had reopened to the West in the 1850s, and began to modernize, both men and women began to wear Westernized dress, as well as traditional styles. For Victorians such as Liberty, this change disrupted their view of the East. This ideal was complex, as it had evolved over time, shaped by Western perceptions of difference, and reinterpretations of Eastern design that responded to the Orient as the opposite of industrialized Western countries. While the late 19th-century cult of Japan tended to see the East as static, in contrast to Western fashion's swiftly changing styles, Japan itself was quickly absorbing Western influence to reconfigure its own designs.

Local and global

At the start of the 20th century, the fashion industry had therefore evolved from this complex history. While on the one hand, certain countries, especially those under the generalized Western idea of the East, were seen as a rich and sensual source of inspiration, on the other Westerners tended to view the rest of the world as a resource rather than as equals. Trade networks had shifted and transformed over the centuries, but tended to be controlled by Western powers. The fashion industry had global trade links, but it was yet to become globalized, with corporations that were truly international, and fully fledged fashion systems in multiple countries across the world. This is not to say that fashion did not exist outside the West; style changes emerged on other continents, fuelled by local tastes and social structures. However, cyclical fashions generated by designers, manufacturers, and promoted by

retailers and media were to evolve in the second half of the 20th century.

During the interwar period, French haute couture was very powerful and drove international trends. However, its success was predicated on sales not just of individually made garments, but also of designs that manufacturers in other countries could buy and reproduce. At the same time, cities such as London and New York sought to establish their own fashion identities, with increased focus on designer names and fashion-led manufacturing. This process laid the foundations for the fashion industry's post-war acceleration and growth. High fashion was still enthralled by French style, but other countries were fast developing their own marketable fashion signature, particularly in terms of ready-to-wear. America is a case in point: in the 1930s and 1940s, its fashions were frequently promoted in relation to patriotic myths of a coherent national identity. By the early 1950s, although it continued to use emblems of Americanness in its design and imagery, it was more concerned to promote its international fashion signature and status. This is illustrated by American *Vogue*, which increasingly covered a wider range of countries' fashion collections during the 1950s. Alongside Paris and London, which had long featured in its editorial and advertising pages, collections from Dublin, Rome, and Madrid were covered each season. Even though *Vogue*'s focus remained European and Western, this showed how aspirations towards high fashion status had spread.

As these cities began to emerge as style centres, America built on its strengths in simple, easy-to-wear separates and neat dresses. These were sold to wider markets in the post-war period, but most importantly, denim jeans and sportswear came to dominate the global scene after the war. Worn by all ages, genders, ethnicities, and classes, denim was the most significant factor in the globalization of a recognizable style statement. Although jeans are not necessarily automatically fashion, their rise in status expressed consumer desire for clothing that could be worn with a range of

formal and informal garments and could be adapted to fit with individual style. By the early 21st century, jeans represented a huge international market, and although this could be read as a homogenization of fashion and therefore of global visual identity, denim is diverse and can in fact expose national, regional, subcultural, and individual identity through its myriad permutations. In Brazil, for example, Mamao Verde produced skintight denim jeans with sparkling decoration to emphasize the wearer's curves. In Japan, denim was fetishized, and collectors sought out rare pairs of vintage Levis, as well as indigenous brands such as Evisu, which included baggy-cut jeans decorated with its signature logo print. It is not just designer and sought-after brands that provided denim with its diversity. Individuals created their own distinct denim, as the indigo dye becomes fainter through washing and creases in line with the wearer's body. Jeans are frequently customized, or worn with a mixture of second-hand and new clothes to create micro fashions particular to a specific area. In this way, homogenization and globalization could be resisted or at least given a different feel in relation to local rather than international impulses, and through the wearer's creativity.

Wearers' individualization of their clothing and accessories can thus complicate simple readings of globalization's impact on visual style. However, in many cases big brands' spread across the globe can lead to high streets, shopping malls, and airport duty-free lounges all too often comprising the same familiar labels. The quick response of chains such as Zara to local fashions spotted on the streets and integrated into their designs can lead to differences in what is sold in their branches in different countries and even cities. However, in other cases, Western brands' dominance of the marketplace can lead to visual similarities between fashion styles amongst particular social classes internationally, as was the case amongst the elite in earlier periods. The same brands of sunglasses, handbags, and other accessories are shown in international fashion magazines, and bought by consumers who wish to attain what might be called this global high-fashion style. Its precursor is

clearly Parisian couture's domination since the 17th century, but by the time the international jetset of the 1970s had emerged, it might just as easily be an Italian or American label that was coveted. The wealthy in many cities adhere to their own version of this style, to produce transnational fashions that rely more on social than geographical boundaries.

However, nuances still emerge, in relation to national ideals of beauty and gender, for example. Age is another important factor that shapes how such fashions are interpreted. In the 1990s, British brand Burberry's signature scarves, trench coats, and handbags became popular amongst South Korean youth. While this can be seen as an example of homogenization, the brand's signature check was worn in a different way. In Korea, as in Japan, a complete designer outfit was aspired to, with everything from shoes to hairgrips heavily branded. This conspicuous consumption was not fashionable in the West, where emphasis was placed on a wearer's ability to combine labels and mix them with vintage or non-branded goods, and logos were only periodically fashionable. Young South Koreans therefore subverted Burberry's brand image of restrained British upper-class taste by their enthusiasm for its goods.

Margaret Maynard has identified this complex interplay between increased international merging of fashion trends as a result in part of global brands, as a product of changes in the late 20th century. She argues that this marks the moment that globalization began to impact economic, political, and social life, therefore affecting the fashion industry. She cites international events including the collapse of communism, demise of postcolonial rule, growth of multinational corporations and banking, and world media and Internet, as responsible for greater dissemination and circulation of fashion garments and imagery, and fashion markets awakening in myriad countries. The growth in international travel and immigration patterns has speeded up the breakdown of boundaries and the concomitant growth of

globalization. This process has led to ethical issues in terms of, for example, Western capitalism's search for cheaper manufacturing, and the parallel rise of Fast Fashion has seen its own industrial production decline. Brands from luxury names such as Gucci to mass-market Gap have outsourced their manufacturing to countries including China, Vietnam, and the Philippines. This has led to globalization's most pernicious effect – workers' exploitation. It has become difficult to track suppliers and maintain factory standards. Workers are abused and underpaid, and are frequently drawn from the most vulnerable sections of the population, for example children or recent immigrants. Globalization has therefore provided a mask behind which unjust industrial manufacturing practices can hide. The fashion industries' vast geographical scope has made it all too easy for non-unionized labour to be used to provide cheap fashions for the growing international market. It has also meant the luxury conglomerates, notably LMVH, now dominate the industry, alongside companies including sportswear-based and youth-orientated labels such as Diesel and Nike. However, Maynard contends that local differences are still able to break through this potentially homogenized mass of globally available goods, and therefore a completely uniform look or idea of fashion has not been universally imposed.

Senegal's fashions are an example of this locally formed popular culture, which appropriates from, but can equally resist, the mass culture of fashion produced by huge corporations. Senegalese youth look to diverse global influences in their style, and confidently integrate European and Islamic elements, as well as different types of fashion. While jeans and African-American trends are apparent, young people also commission more formal designs from local tailors. Hudita Nina Mustafa has shown how important self-presentation has been in Senegal since well before the French colonial period. She describes how men and women wear hybrid Eurafrican fashions, as well as garments that are specific to their region. The capital Dakar's highly flexible

tailors, dressmakers, and designers, including Oumou Sy, who also exports her work to Tunisia, Switzerland, and France, encapsulate this sophisticated, cosmopolitan use of fashion. They create garments that are inspired by current local styles, traditional forms of dyeing and decoration, international celebrities, and French couture. Global networks of trade enable Senegalese traders to commission fabric designs from Northern Europe, buy textiles in Nigeria, and trade in Europe, America, and the Middle East. The country's fashion system therefore integrates local and global impulses to create fashions that connect to consumers. It is at once part of the globalized fashion industry, yet retains its own commercial patterns and aesthetic tastes. Dakar's vibrancy as a fashion capital exemplifies the ways in which fashion industries can coexist and overlap in the 21st century. Indeed, as Leslie W. Rabine has suggested, Africa as a whole incorporates a variety of fashion and entrepreneurial types that work both within and on the edges of the Western capitalist industry, 'through such networks, peopled by suitcase vendors who transport their goods with them in suitcases and trunks, producers and consumers create transnational popular culture forms'. Thus, street traders, like the pedlars of earlier periods, as well as travellers and tourists, and long-term and permanent immigrants spread fashion garments and accessories across the globe. These formal and informal methods blur clear-cut distinctions of national identity, just as the spread of global branded goods do. In fact, combined with the international trade in second-hand clothes, they help to resist the homogenized ideal that such brands all too often represent.

High-fashion collections shown in European and other cities also incorporate notions of transnational designs, which fuse references from a wide range of cultures and ethnicities, without being clearly defined by any one geographical region. Manish Arora's work is an example of this, since he combines East and West in terms of both design and decoration. Unlike early 20th-century designers such as Paul Poiret, who used Middle- and Far-Eastern influences from the perspective of a colonial Westerner, Arora refuses such

hicrarchies. However, the 'Orientalizing' influence of the West is deeply embedded in visual and material culture. Questions remain about who produces, controls, and dominates the use of images and fashion styles. Cultural appropriation abounds in fashion, and provides a rich palette of cross-fertilization in ideas, styles, and colours. However, José Teunissen has asked:

> the image exotic cultures have of themselves is often determined by the dominant West. What is Indian after all? Is it what people of India call Indian, or what we in the West, with our colonial past – once labelled Indian?

In the early 21st century, this has remained a fraught issue, as has the question of whether it is different for a Western designer to use 'exotic' references, given the long, and hugely problematic, histories of colonial rule and domination. Postmodernism may have provided justification for designers' playful cross-fertilization of ideas from a wide range of ethnic and historical reference points, as seen in John Galliano's work, for example. However, it cannot completely erase contexts in which the fashion industry evolved or the historical meanings of such appropriations to enable an equal exchange, either in design and aesthetic terms, or in other aspects of the industry such as trade. As more and more countries begin to promote their fashions internationally, these differences will perhaps diminish. This process will not be complete until a sufficient number of designers, luxury brands, and ready-to-wear manufacturers from non-Western countries have the same power and reach as LVMH and its peers.

Fashion weeks, which group together a particular country's or city's designers to show their seasonal collections, continue to provide a focus from which to promote an area's visual identity as well as to develop and provide a platform for its fashion designers. Fashion is a huge industry with great economic and cultural significance, and the spread of fashion weeks in various South American cities, for example, shows how they can begin to

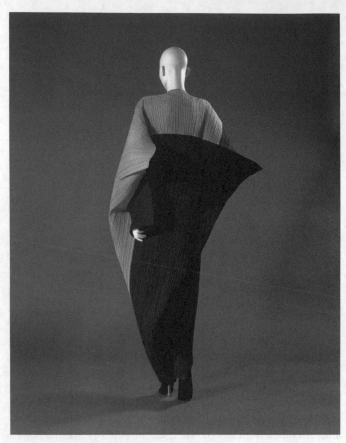

20. Issey Miyake's angular pleating, from 1990

establish alternative fashion centres. The impact that non-Western designers can have on the globalized market was demonstrated by the huge success of Japanese designers who showed in Paris from the late 1970s and early 1980s. At this time, it was still necessary for designers to show within an established fashion week to gain sufficient publicity and exposure to international store buyers.

Japanese designers such as Yohji Yamamoto, Rei Kawakubo of Comme des Garçons, Kenzo, and Issey Miyake's work shocked the Western fashion world into the realization that high fashion could emanate from beyond its confines. Importantly, Japanese fashion also provided an alternative vision of body and fabric and the dynamic between them.

Issey Miyake, for example, produced clothes that overturned Western ideals of beauty and form and presented tightly pleated textiles sculpted into points that pulled out from the figure. He recreated femininity in line with architectural notions of space, rather than cutting fabric in towards the natural form. His clothes often swept upwards, and jutted out to emphasize the contrast between body and garment. His work is carried out on the international stage, shown and sold in cities across the world. However, in the 1990s, Miyake commented that despite, or perhaps because, global 'boundaries are being destroyed or re-defined before our eyes, daily . . . I think they are necessary. After all, boundaries are the expression of culture and history.' His desire to maintain his Japanese identity, yet simultaneously to produce designs with international resonance and appeal, is at the heart of questions about the fashion industry's globalization. Trade networks, production, consumption, and design have all increasingly become tied to globalized fashion systems since the late 20th century. Globalized fashion has not completely repressed either local or individual expression through fashion, either for designers or for wearers. However, the recession that developed in the early 21st century may accelerate the development of non-Western fashion design, built upon already well-established production patterns, and produce a dramatic shift in the balance of fashion power.

Conclusion

Teri Agins' significant 1999 book *The End of Fashion* described what she saw as the industry's shift from fashion to clothing in the late 20th century. She argued that French couture had been slow to realize the need to focus on wearable classics at affordable prices, and was surviving on its franchises, in particular its worldwide perfume sales. At the same time, big European corporations had realized that American designers such as Michael Kors at Celine could bring in more sales for their stable of brands than the more dramatic British designers such as John Galliano at Dior. Agins outlined designers' focus on innovation in marketing rather than fashion design. Concomitant with this was the public's exhaustion with fashion, and increased interest in high-street chains including Gap and Banana Republic, which were reliable for wardrobe staples, as well as occasionally setting fashions. Agins' argument was convincing, and came at the end of a decade that had seen international recession and market crashes in the Far East. As she noted, since minimalist designs had been fashionable, pared-down dressing was itself part of a trend away from elaborate fashions.

So, did fashion end in the 1990s? Was this the triumph of clothing? Agins certainly showed an important trend in the international market. However, what is perhaps most interesting is that it was a trend. As she said herself, minimalism was a fashion at the time,

and thus its presence at all levels of the market was itself part of this fashion. It is important to note that other trends were also apparent. Young designers such as Alexander McQueen began successful careers in the early 1990s, and built labels predicated not just on franchising but on innovation in design. Significantly, the mid-1990s, the moment Agins identified as the turning point away from fashion-led clothing, was also the stage when a growth in interest in craft skills and detail began to emerge in designers including Matthew Williamson's work. Perhaps what Agins identified was not the end of fashion, but rather an example of its flexible and constantly mutating form. As cultural, social, and economic contexts change, so too do designers' inspirations, and consumers' needs and, more importantly, desires.

Certainly, there was a major trend towards workwear-inspired fashions at street and high fashion levels, which encompassed everything from cargo pants to grunge, and stark, intellectual minimalism from designers such as Jil Sander. However, it is important to remember that various fashions exist simultaneously; there was also a revival of goth fashions, and dark and fetishistic styles in high fashion. Alongside this were Williamson's fruit-coloured fashions, which brought luxury details and vibrant prints back into focus. While America still favoured Gap, in Europe it declined, its loose fit and anonymous style unable to compete with the rise of Topshop in Britain and Kookai in France, for example, as fashionable and exciting alternatives. Agins therefore wrote of a tipping point in American-focused fashion and clothing tastes and lifestyle, just as alternatives to this vision were beginning to take hold of the public's imagination. She was therefore right to identify the importance of this moment in fashion history, but fashion's apparent demise was actually the moment before its revival as a driving force from high street to couture level.

What Agins' work did was remind us of fashion's inherent ability to absorb outside influences, and to reinvent itself in line with, and sometimes even in anticipation of, new lifestyles and tastes. By the

early 21st century, clothing was still an important part of the market, as it always had been, and, as Agins stated, wardrobe classics were as needed as ever. However, new couturiers, such as Alber Elbaz at Lanvin, Nicolas Ghesquiere at Balenciaga, Stefano Pilati at Yves Saint Laurent, and Christoph Decarnin at Balmain, caused international excitement about French fashion once again. Even if most could only aspire to buy their iconic handbags, their seasonal style statements were quickly seen in high-street chains. Younger designers in America still drew upon the country's history for leadership in sportswear, but names including Proenza Schouler and Rodarte translated these styles into luxurious forms, decorated with couture-inspired detailing. In London, new designers such as Todd Lynn, Louise Goldin, and Christopher Kane showed a revived interest in fine tailoring, inventive and colourful knitwear, and seasonally changing silhouettes, respectively.

Other cities across the globe were equally keen to tap into fashion as an exciting visual and material form. This was perhaps most clearly seen in India, China, South America, and the Pacific Rim where fashion weeks began to promote indigenous designers and seek new national and international names. In China, investments in production capacities were superseded by interest in design education and promotional trades, in order to build towards a strong fashion design profile for the future. In India and Russia, rising middle and upper-middle classes meant that a new cadre of people were keen to express their status and taste through clothing. New fashion magazines sprang up, both national editions of fashion staples such as *Vogue*, *Elle*, and *Marie Claire*, but also new titles that were inspired by local styles.

At street level, fashion was ever more evident, catalogued on websites such as http://www.thesartorialist.com, as well as sites that focused on the style of people in particular cities, from Stockholm to Sydney. These demonstrated fashion's continued ability to express individuality in permutations of existing fashions

and emerging youth fashions. Subcultural fashion was equally vibrant, including reinventions of 1980s goth styles that spread internationally, and the allied teenage emo fashions. Club fashions were increasingly flamboyant, and referenced 1980s New Romanticism and Rave. As ever, fashion drew on its own history in order to move forward. It cross-referenced its past, and brought together new configurations of style. Thus, Christopher Kane was inspired by Azzedine Alaia's 1980s figure-hugging dresses and Versace's early 1990s vibrancy, but produced fashions that were new and fresh. New Rave reinvented its predecessor's neon colours and oversized slogan T-shirts. In each case, the new century saw an interest in volume and colour, which had been missing in much 1990s fashion.

The early 21st century also witnessed a growing number of ethically inspired labels and websites, which focused on fashion's impact on the planet as well as concern about workers' rights. This represented an important response to reports of exploitation in factories from Mexico to India, where garments were made for big Western brands. Fashion's need to address its production methods was a significant shift. While there had been calls for this since the mid-19th century, responses had been intermittent. It remains to be seen whether this boom in ethical fashion can infiltrate the industry as a whole and make permanent, far-reaching changes to the way textiles are made and clothing produced. It is to be hoped that this is a long-term trend, and not just a brief fashion.

Fashion had simultaneously grown as a subject of academic study, with increasing numbers of books and journals produced to examine its nature, status, and meaning. International museums presented fashion exhibitions to great acclaim and enormous fashion interest. At the other end of the market, the rise of celebrity culture spread fashions more quickly than even Hollywood had in its heyday. Cumulatively, these varied aspects of social, cultural, and political lifestyles and attitudes connected to the birth and dissemination of fashion, and its increasingly globalized character.

127

Fashion had not ended, therefore, but it had altered, and it was, potentially, on the brink of another major shift. As non-Western fashion systems grew in confidence, and recession set in, power could potentially shift towards the East. While it is unlikely that the Western fashion industry, which has evolved since the Renaissance, will be subsumed, it will have to adapt quickly to respond effectively to the global challenge.

References

Introduction

Arnold, Janet, *Patterns of Fashion: The Cut and Construction of Clothes* (Drama Book Publishers, 2008).

Arnold, Rebecca, *The American Look: Fashion, Sportswear and the Image of Women in 1930s and 1940s New York* (I. B. Tauris, 2009).

Barthes, Roland, *The Language of Fashion* (Berg, 2006).

—— *The Fashion System* (Jonathan Cape, 1985).

Breward, Christopher, *The Hidden Consumer: Masculinities, Fashion and City Life, 1860–1914* (Manchester University Press, 1999).

Entwistle, Joanne, *The Fashioned Body: Fashion, Dress and Modern Social Theory* (Polity Press, 2000).

Evans, Caroline, *Fashion at the Edge: Spectacle, Modernity and Deathliness* (Yale, 2007).

Hollander, Anne, *Seeing through Clothes* (University of California Press, 1993).

Lemire, Beverly, *Dress, Culture and Commerce* (Palgrave Macmillan, 1997).

Miller, Danny and Mukulika Banerjee, *The Sari* (Berg, 2003).

Ribeiro, Aileen, *Fashion and Fiction: Dress in Art and Literature in Stuart Britain* (Yale, 2005).

Wilson, Elizabeth, *Adorned in Dreams: Fashion and Modernity* (I. B. Tauris, 2003).

Chapter 1: Designers

Baillén, Claude, *Chanel Solitaire* (Collins, 1973), p. 69.

Beaton, Cecil, *The Glass of Fashion* (Cassell, 1989), p. 8.

Carter, Ernestine, 'Gabrielle "Coco" Chanel, 1883–1971: Magic of Self', in *Magic Names of Fashion* (Weidenfeld and Nicholson, 1980), pp. 52–66.

Dickens, Charles, *All Year Round* (London, February 1863), quoted in Elizabeth Ann Coleman, *The Opulent Era: Fashion of Worth, Doucet and Pingat* (Thames and Hudson, 1989), p. 15.

Frankel, Susannah, *Visionaries: Interviews with Designers* (V&A Publications, 2001), pp. 34–5.

Rawsthorn, Alice, *Yves Saint Laurent: A Biography* (HarperCollins, 1996), p. 90.

Settle, Alison, *Clothes Line* (Methuen, 1937), p. 4.

Tetart-Vittu, Françoise, 'The French-English Go-Between: "*Le Modèle de Paris*" or the Beginning of the Designer, 1820–1880', in *Costume*, no. 26 (1992), pp. 40–5.

Williams, Beryl, *Young Faces in Fashion* (J. B. Lippincott, 1956), p. 145.

Chapter 2: Art

Apraxine, Pierre and Xavier Demarge, '*La Divine Comtesse*': *Photographs of the Comtesse de Castiglione* (Yale University Press, 2000), p. 13.

Hollander, Anne, *Seeing through Clothes* (University of California Press, 1993), p. xi.

Oliphant, Margaret, *Dress* (London, 1878), p. 4.

Ribeiro, Aileen, 'Fashion and Whistler', in Margaret F. MacDonald, Susan Grace Galassi, and Aileen Ribeiro, *Whistler, Women and Fashion* (The Frick Collection and Yale University Press, 2003), p. 19.

Stepanova, Vavara, 'Tasks of the Artist in Textile Production', in S. Novoer (ed.), *The Future is Our Only Goal*, p. 191, quoted in Radu Stern, *Against Fashion: Clothing as Art, 1850–1930* (MIT Press, 2004), p. 55.

Swanson, Carl, 'The Prada Armada', *New York Times Magazine* (16 April 2006).

Troy, Nancy, *Couture Culture: A Study in Modern Art and Fashion* (MIT Press, 2003), p. 7.

Warhol, Andy, *The Philosophy of Andy Warhol (From A to B and Back Again)* (Harcourt Brace and Company, 1977), p. 92.

Wollen, Peter, 'Addressing the Century', in Peter Wollen (ed.), *Addressing the Century: 100 Years of Art and Fashion* (Hayward Gallery Publishing, 1998), p. 16.

Chapter 3: Industry

Agins, Teri, *The End of Fashion: The Mass Marketing of the Clothing Business* (William Morrow, 1999), p. 5.

Godley, Andrew, 'The Emergence of Mass Production in the UK Clothing Industry', pp. 8–25, in I. Taplin and J. Winterton (eds.), *Restructuring in a Labour Intensive Industry: The UK Clothing Industry in Transition* (Avebury, 1996), p. 12.

Godley, Andrew, Anne Kershen, and Raphael Schapiro, 'Fashion and its Impact on the Economic Development of London's East End Womenswear Industry, 1929–62: The Case of Ellis and Goldstein', *Textile History*, vol. 34, no. 2 (November 2003), pp. 214–20.

Kidwell, Claudia and Margaret C. Christman, *Suiting Everyone: The Democratization of Clothing in America* (Smithsonian Institution, 1974), p. 39.

Lemire, Beverley, *Dress, Commerce and Culture: The English Clothing Trade before the Factory, 1660–1800* (Macmillan, 1997), pp. 122–4.

Moses, Elias, *The Growth of an Important Branch of British Industry: The Ready-Made Clothing System* (London: 1860), pp. 4–5.

Perrot, Philippe, *Fashioning the Bourgeoisie: A History of Clothing in the Nineteenth Century* (Princeton University Press, 1994), p. 54.

Chapter 4: Shopping

http://www.doverstreetmarket.com

Benson, Susan Porter, *Counter Cultures: Saleswomen, Managers, and Customers in American Department Stores, 1890-1940* (University of Illinois Press, 1988), p. 76.

Collins, Kenneth, speaking to the Fashion Group, New York, 13 September 1938, Box 73, File 2, Fashion Group Archives, New York Public Library.

Quant, Mary, *Quant by Quant* (Cassell, 1966), p. 43.

Rappaport, Erika, *Shopping for Pleasure: Women in the Making of London's West End* (Princeton University Press, 2000), p. 5.

Roche, Daniel, *A History of Everyday Things: The Birth of Consumption in France, 1600–1800* (Cambridge University Press, 2000), p. 213.

Smith, Woodruff D., *Consumption and the Making of Respectability, 1600–1800* (Routledge, 2002), pp. 44 –51.

Thomas, Dana, *Deluxe: How Luxury Lost its Lustre* (Allen Lane, 2007), p. 300.

Chapter 5: Ethics

Arletty, quoted in 'Pour ou Contre les Pantalonnées', *L'Œuvre* (7 February 1942), cited in Dominique Veillon, *Fashion under the Occupation* (Berg, 2002), p. 127.

Cho, Margaret, quoted in Michael Slezak, 'Margaret Cho's Not Laughing About Gwen's Harajuku Girls', *Entertainment Weekly*, http://www.ew.com (2 November 2005).

Dunn, Jourdan, quoted in Elizabeth Day, 'How Racism Stalked the London Catwalk', *The Observer* (17 February 2008).

Jonson, Ben, *Epicoene or The Silent Woman*, ed. Roger Holdsworth (A&C Black, 1999), p. 100.

Killerby, Catherine Kovesi, *Sumptuary Law in Italy, 1200–1500* (Clarendon Press, 2002), p. 7.

Limnander, Armand, 'Slow Fashion', *The New York Times* (16 September 2007).

McDougall, Dan, 'The Hidden Face of Primark Fashion', *The Observer* (22 October 2008).

Spectator 49, quoted in Erin Mackie, *Market à la Mode: Fashion, Commodity and Gender in The Tatler and The Spectator* (John Hopkins University Press, 1997), p. 174.

Stitzel, Judd, *Fashioning Socialism: Clothing, Politics and Consumer Culture in East Germany* (Berg, 2005), p. 3.

Wolf, Jaime, 'And You Thought Abercrombie and Fitch Was Pushing It?', *The New York Times* (23 April 2006).

Chapter 6: Globalization

Armstrong, Lisa, 'A Little Local Colour Goes a Long Way', *The Times* (16 February 2006).

Asome, Caroline and Alan Hamilton, 'Former Duckling Grows into Swan of Global Fashion', *The Times* (15 February 2005).

Belfanti, Carlo Marco, 'Was Fashion a European Invention?', in *Journal of Global History*, no. 3 (2008), pp. 419–43.

Jones, Ann Rosalind and Peter Stallybrass, *Renaissance Clothing and the Materials of Memory* (Cambridge University Press, 2001), p. 57.

Maynard, Margaret, *Dress and Globalisation* (Manchester University Press, 2004), pp. 2–5.

Miyake, Issey, quoted in Mark Holborn, *Issey Miyake* (Taschen, 1995), p. 16.

Mustafa, Hudita Nina, 'La Mode Dakaroise: Elegance, Transnationalism and an African Fashion Capital', in Christopher Breward and David Gilbert (eds.), *Fashion's World Cities* (Berg, 2006), pp. 177–200.

Nagrath, Sumati, 'Local Roots of Global Ambitions: A Look at the Role of the India Fashion Week in the Development of the Indian Fashion Industry', in Jan Brand and José Teunissen (eds.), *Global Fashion, Local Tradition: On the Globalisation of Fashion* (Terra, 2005), p. 49.

Neissen, Sandra, 'The Prism of Fashion: Temptation, Resistance and Trade', in Jan Brand and José Teunissen (eds.), *Global Fashion, Local Tradition: On the Globalisation of Fashion* (Terra, 2005), p. 165.

Rabine, Leslie W., *The Global Circulation of African Fashion* (Berg, 2002), p. 3.

Ribeiro, Aileen, *Dress in Eighteenth Century Europe, 1715–1789* (Batsford, 1984), pp. 169–70.

Sato, Tomoko and Toshio Watanabe, 'The Aesthetic Dialogue Examined: Japan and Britain, 1850–1930', in Tomoko Sato and Toshio Watanabe (eds.), *Japan and Britain: An Aesthetic Dialogue, 1850–1930* (Lund Humphries, 1991), pp. 38–40.

Styles, John, 'Tudor and Stuart Britain, 1500–1714: What was New?', in Michael Snodin and John Styles (eds.), *Design and the Decorative Arts: Britain 1500–1900* (V&A Publications, 2001), p. 136.

Teunissen, José, 'Global Fashion/Local Tradition: On the Globalisation of Fashion', in Jan Brand and José Teunissen (eds.), *Global Fashion/Local Tradition: On the Globalisation of Fashion* (Terra, 2005), p. 11.

Vicente, Marta V., *Clothing the Spanish Empire: Families and the Calico Trade in the Early Modern Atlantic World* (Palgrave Macmillan, 2006), pp. 65–6.

Further reading

Introduction

Breward, Christopher, *The Culture of Fashion: A New History of Fashionable Dress* (Manchester University Press, 1995).

Bruzzi, Stella and Pamela Church Gibson, *Fashion Cultures: Theories, Explorations and Analysis* (Routledge, 2000).

Jarvis, Anthea, *Methodology* Special Issue, *Fashion Theory: The Journal of Dress, Body and Culture*, vol. 2, issue 4 (November 1998).

Kawamura, Yuniya, *Fashion-ology: An Introduction to Fashion Studies* (Berg, 2004).

Kaiser, Susan, *Social Psychology of Clothing: Symbolic Appearances in Context* (Fairchild, 2002).

Purdy, Daniel Leonhard (ed.), *The Rise of Fashion: A Reader* (University of Minnesota Press, 2004).

Chapter 1: Designers

Aoiki, Shoichi, *Fresh Fruits* (Phaidon, 2005).

Kawamura, Yuniya, *The Japanese Revolution in Paris Fashion* (Berg, 2004).

Muggleton, David, *Inside Subculture:The Postmodern Meaning of Style* (Berg, 2000).

Seeling, Charlotte, *Fashion: The Century of Designers, 1900–1999* (Konemann, 2000).

Steele, Valerie and John Major, *China Chic: East Meets West* (Yale, 1999).

Chapter 2: Art

Francis, Mark and Margery King, *The Warhol Look: Glamour, Style, Fashion* (Little, Brown and Company, 1997).

Martin, Richard, *Fashion and Surrealism* (Thames and Hudson, 1989).

Radford, Robert, 'Dangerous Liaisons: Art, Fashion and Individualism', in *Fashion Theory: The Journal of Dress, Body and Culture*, vol. 2, issue 2 (June 1998).

Ribeiro, Aileen, *The Art of Dress: Fashion in England and France, 1750–1820* (Yale, 1995).

Townsend, Chris, *Rapture: Art's Seduction by Fashion since 1970* (Thames and Hudson, 2002).

Winkel, Marieke de, *Fashion and Fancy: Dress and Meaning in Rembrandt's Painting* (Amsterdam University Press, 2006).

Chapter 3: Industry

Gereffi, Gary, David Spencer, and Jennifer Bair (eds.), *Free Trade and Uneven Development: The North American Apparel Industry after NAFTA* (Temple University Press, 2002).

Green, Nancy, *Ready-to-Wear, Ready-to-Work: A Century of Industry and Immigrants in Paris and New York* (Duke University Press, 1997).

Jobling, Paul, *Fashion Spreads: Word and Image in Fashion Photography since 1980* (Berg, 1999).

McRobbie, Angela, *British Fashion Design: Rag Trade or Image Industry?* (Routledge, 1998).

Phizacklea, Annie, *Unpacking the Fashion Industry: Gender, Racism and Class in Production* (Routledge, 1990).

Tulloch, Carol (ed.), *Fashion Photography*, Special Edition of *Fashion Theory: Journal of Dress, Body and Culture*, vol. 6, issue 1 (February 2002).

Chapter 4: Shopping

Benson, John and Laura Ugolini, *Cultures of Selling: Perspectives on Consumption and Society since 1700* (Ashgate, 2006).

Berg, Maxine and Helen Clifford (eds.), *Consumers and Luxury: Consumer Culture in Europe, 1650–1850* (Manchester University Press, 1999).

Lancaster, Bill, *The Department Store: A Social History* (Leicester University Press, 1995).

Leach, William, *Land of Desire: Merchants, Power and the Rise of a New American Culture* (Vintage, 1993).

Richardson, Catherine (ed.), *Clothing Culture, 1350–1650* (Ashgate, 2004).

Shields, Rob, *Lifestyle Shopping: The Subject of Consumption* (Routledge, 1992).

Worth, Rachel, *Fashion for the People: A History of Clothing at Marks and Spencer* (Berg, 2007).

Chapter 5: Ethics

Arnold, Rebecca, *Fashion, Desire and Anxiety: Image and Morality in the Twentieth Century* (I. B. Tauris, 2001).

Black, Sandy, *Eco-Chic: The Fashion Paradox* (Black Dog, 2008).

Guenther, Irene, *Nazi Chic: Fashioning Women in the Third Reich* (Berg, 2005).

Ribeiro, Aileen, *Dress and Morality* (Berg, 2003).

Ross, Andrew (ed.), *No Sweat: Fashion, Free Trade and the Rights of Garment Workers* (Verso, 1997).

Chapter 6: Globalization

Bhachu, Parminder, *Dangerous Designs: Asian Women Fashion the Diaspora Economies* (Routledge, 2004).

Clark, Hazel and Eugenia Paulicelli (eds.), *The Fabric of Cultures: Fashion, Identity, Globalization* (Routledge, 2008).

Eicher, Joanne B. (ed.), *Dress and Ethnicity: Change across Space and Time* (Berg, 1999).

Kuchler, Susanne and Danny Miller, *Clothing as Material Culture* (Berg, 2005).

Niessen, Sandra, Ann Marie Leshkowich, and Carla Jones (eds.), *Re-Orienting Fashion* (Berg, 2003).

Index

Fashion